IMAGES
of America

HOUGHTON COUNTY
1870–1920

Published by Arcadia Publishing
Charleston, South Carolina

Printed in the United States of America

Library of Congress Catalog Card Number: 2006920836

For all general information contact Arcadia Publishing at:
Telephone 843-853-2070
Fax 843-853-0044
E-mail sales@arcadiapublishing.com
For customer service and orders:
Toll-Free 1-888-313-2665

Visit us on the Internet at www.arcadiapublishing.com

To my late grandmother Addie, who instilled in me a love of history.

CONTENTS

ACKNOWLEDGMENTS

One hundred and forty years ago, in 1866, the Civil War had just ended and Pres. Abraham Lincoln had been assassinated. Despite the extreme cost of this war, and the terrible sense of loss Americans felt, there was an undercurrent of optimism in the land. It was this optimism and forward thinking that brought John H. Forster, Ransom Shelden, Richard Edwards, John Chassell, R. L. Hoar, C. C. Douglass, and other pioneers of Houghton County together to found the Houghton County Historical Society and Mining Institute. This author got gooseflesh at the opportunity to touch and republish photographs that were taken in these early years by the likes of Sen. J. H. Forster (my predecessor). It is impossible to thank all the volunteers over the years who have kept the wonderful legacy of the archive. The Houghton County Historical Society's Perl Merrill Archive and Library is a treasure beyond measure for researching the history of the area. All images that appear in this book, unless otherwise noted, are from these archives.

I would like to extend my gratitude to several people at the Houghton County Historical Society, volunteers and staff, who were so helpful with this project. Douglas Jones, our staff graphics and media specialist, was a true soldier on this project, and deserves much credit. Florence Bashaw, our volunteer staff archivist, found the necessary images from a collection of huge proportions. Gloria Walli, our office assistant and cataloging specialist, did just about everything else.

My special thanks go to Dick Rupley, fellow trustee, head of the society's Forster Press, and professional historian, for being a sounding board for my ideas.

There are several others who contributed to this book through their writing, inspiration, and enthusiasm for the wonderful history of this county. Specifically, I wish to thank David Halkola, Jay Rowe, John Siller, Don Nelson, Clarence Monette, Jeanne Ellis, Rudi Maki, George Anderson, Kevin Musser, Ed Yarbrough, Ed Koeppel, and Leo Chaput for their many contributions toward preserving their community's history. I would also like to remember the late Dr. Palmer Throop of the University of Michigan History Department for the inspiration that ultimately led to the writing of this book.

And by no means last, I am grateful to my wonderful wife, friend, and companion, Rochelle, for her love, patience, and support as I worked on this project.

INTRODUCTION

The history of Houghton County actually starts 6,500 years ago, when the first Native American residents dug native copper from fissures in the lava that comprises the Keweenaw Peninsula. Using fire and heavy stone hammers to free the copper, they traded it all the way to the shores of the Gulf of Mexico. Some of this traded copper, handed down within various cultures, came to the attention of 16th- and 17th-century French explorers. The Native Americans described it as coming from "great hills of copper" on the shores of the lakes in the West.

Fr. Claude Allouez, a Jesuit missionary who established a mission among the Ottawa in the 1660s, wrote reports of abundant copper deposits in the area. About 100 years went by before Alexander Henry, an English explorer, found copper at the mouth of the Ontonagon River. His reports brought about an unsuccessful attempt to mine copper in 1771–1772, near the site of the Victoria Mine. Due to the intercession of the American Revolution, the practical mining of copper would have to wait until the late 1840s.

In the 1820s, the federal government delegated the evaluation of resources in the Superior region to Henry Rowe Schoolcraft. As a result of this expedition, and Schoolcraft's friendship with a young physician named Douglass Houghton, he planned another journey to the Keweenaw for 1831–1832. The findings of this second expedition influenced Congress to appropriate funds for the purchase of these lands from the Chippewa Indians. In 1842, the Treaty of LaPointe sealed the deal, granting 25,000 square miles of land to the United States. With the mineral rights secure, and Houghton's reports confirming the stories of massive copper deposits, the first mining boom in American history began. However, Houghton County and its three principal cities—Houghton, Hancock, and Calumet—did not really become the center of all this activity until after the initial part of the boom played out north of the Portage Lake in the Copper Harbor, Eagle Harbor, and Eagle River areas.

One of the first mines opened in the region was the Lake Superior Copper Company, established near Eagle River in 1844. Its beginnings were not without difficulty; at one point, the ship bringing supplies for the winter wrecked, and the 15 men at the mine almost starved to death. The remoteness of this region, and its severe winter weather rapidly separated those who would succeed from those who would fail.

Horace Greeley, known for the saying "Go West, young man," was initially enthralled with the region, even investing in the early Pennsylvania Mine. But after visiting the Keweenaw, he wrote that his lasting impression was not of rich copper deposits, but of clouds of mosquitoes and gnats. He later wrote articles that warned against the risks of investing in mining ventures.

It was not until the discovery of vast amounts of copper in the Amygdaloid and Calumet Conglomerate Lodes, just before and during the Civil War, that the area began to grow rapidly and lose its isolation. By the 1860s, the Marquette, Houghton, and Ontonagon Railroad had opened the area to the rest of the world without the exclusive dependence on ships. Further, by the end of the 19th century, the Copper Range Railroad opened a southern door to the rail center of the nation, Chicago. In the days following the Civil War, the Keweenaw provided pure copper for the needs of the entire nation: wiring, electric lights, telephone and telegraph, as well as the brass and bronze (alloys of copper) so crucial for machinery, construction, and transportation. For example, in this Railway Age, every railroad car had four brass bushings ("the brasses") per wheel, 16 per car. Not until the opening of less expensive places to mine copper did these products come from anywhere other than the Keweenaw, the Copper Country.

The collection of photographs and information presented here is but a small window to a small span of time (1850–1920) in the Keweenaw Peninsula and Houghton County. It was a time when America was growing, reaping the fruits of its vitality, inventiveness, and rich tapestry of immigrants who brought with them enriching ideas and cultures.

One

FOUNDERS AND FINDERS

As a member of the 1820 expedition, Henry Rowe Schoolcraft was charged by territorial Gov. Lewis Cass and secretary of war John C. Calhoun to assess the mineral values of the newly annexed Upper Peninsula of Michigan. The expedition proceeded along the south shore of Lake Superior to the Ontonagon River in search of the fabled Ontonagon copper boulder. Schoolcraft's later reports to Calhoun sparked initial interest in the copper of the region. In 1831, Schoolcraft decided to make another expedition to the Lake Superior area. He had heard of a young physician with training in naturalism who had just moved to Detroit. Douglass Houghton, a graduate of the Rensselaer School in Troy, New York (now Rensselaer Polytechnic Institute), came highly recommended. When Michigan governor Cass heard that Houghton was joining the expedition, he made a special request that he try to inspect the Ontonagon boulder.

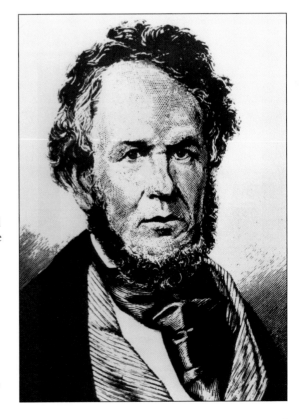

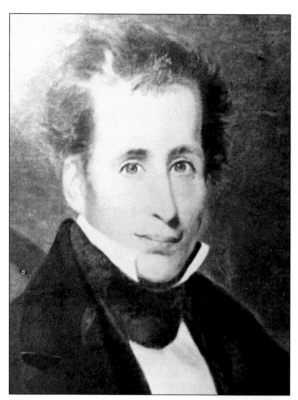

Douglass Houghton has been called the Columbus of the Michigan copper boom. His 1840 expedition as state geologist led to the discoveries at both Copper Harbor and Portage Lake, which contributed to one of the greatest mining rushes in U.S. history. Federal treaties with the Chippewa in place, by 1843 hundreds of requests for permits to prospect in the Keweenaw were being filed. Houghton County was thus named in his honor. (Michigan Historical Collections, Bentley Library, University of Michigan.)

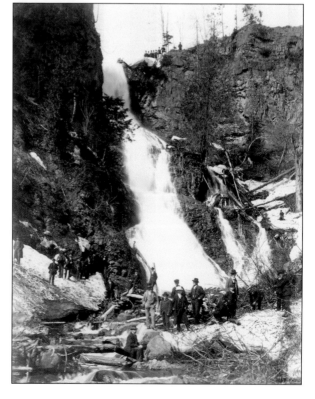

In October 1845, Douglass Houghton drowned in Lake Superior while on a trip to resupply a survey party working up the coast from Eagle Harbor. These falls, also named in his honor, are among the highest in Michigan, and are just outside of Lake Linden. (Photograph by A. F. Isler, Lake Linden.)

Ransom Shelden and his partner opened a store in 1846 to supply miners and explorers coming to the Keweenaw in the vicinity of South Entry. Land mining speculation was also one of their aims. The two gentlemen acquired lands that would eventually develop into the Quincy Mine, the second most productive mine in the region. Sheldon is also credited as the founder of the city of Houghton and Houghton County.

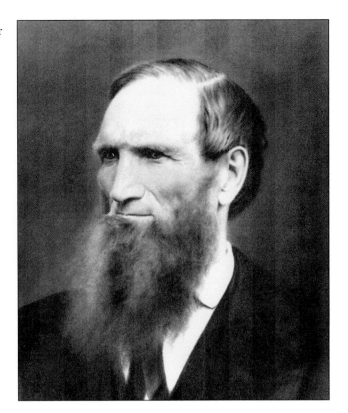

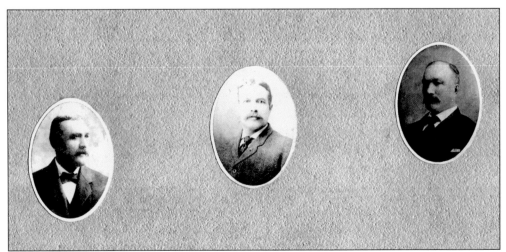

Ransom Shelden had three sons, all of whom played a large role in the development of the area. Pictured here, from left the right, are Ransom B., Carlos D., and George C. Shelden. Both George and Carlos fought in the Civil War, while Ransom B. worked in the family business. Carlos eventually became a U.S. congressman.

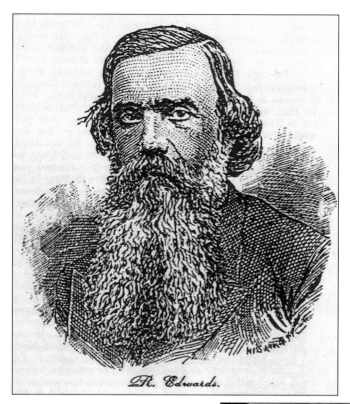

R. Edwards.

Capt. Richard Edwards was one of the most enterprising pioneers of Houghton County. A mining captain from Cornwall, England, he became a mine superintendent supervising several in the Copper District, including the Albion, Sheldon, and Columbia Mines. He and his second son, T. W., worked together on investments. (Western Historical Company.)

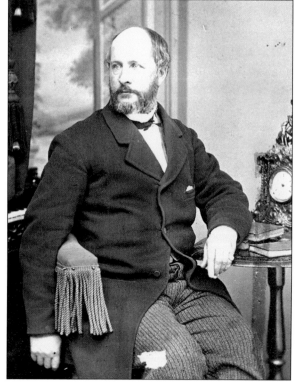

John H. Forster, one of the founders of the Houghton County Historical Society and Mining Institute, is shown here 141 years ago. Born in Erie, Pennsylvania, in 1822, he was a surveyor, mine superintendent, and state senator. He also served as chief engineer of the Portage Ship Canal. At various times, he was superintendent and agent for the Pewabic, Franklin, Sheldon, Columbian, and Douglass Mines. Forster worked in the Lake Survey for the Corps of Engineers.

Two

MINING THE MASS COPPER LODE

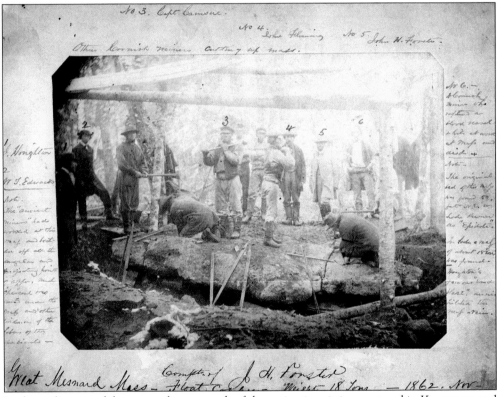

In the early years of the copper boom, much of the action in mining centered in Keweenaw and Ontonagon Counties. Many mines started in those areas were primitive affairs, in which miners seeking masses of copper would work from the rock in the manner shown in this 1862 photograph donated by John W. Forster. Here, the miners are attempting to free the Great Mesnard Mass. Pictured from left to right, labeled one through six in the photograph, are Jay Houghton, W. T. Edwards, captain Camsue, John Fleming, Forster, and "a Cornish miner who ruptured a blood vessel while at work on this mass and died." Forster stated that this mass, weighing 18 tons, had been previously worked by "ancient miners." He further annotated the image by explaining that the mass had been found in a formation called the Epidote Lode.

The Huron, Sheldon, Albion, and other early Houghton County mines worked to find fissures and masses of native copper and extract these from underground, or even from on the surface of their claims. The Lake Superior Company Mill of 1845 used a 200-pound iron stamp, dropping one foot, to break rock. It was a major flop. (Report to the Trustees Lake Superior Copper Company, 1845.)

In 1843, Pittsburgh druggist John Hays moved to the Copper Country to prospect with the support of a group of investors from Pittsburgh and Boston. He and a partner discovered the Cliff Mine site while making their way across the peninsula after being blown ashore by a Lake Superior squall. (Michigan Technological University Archives and Copper Country Historical Collections, Michigan Technological University.)

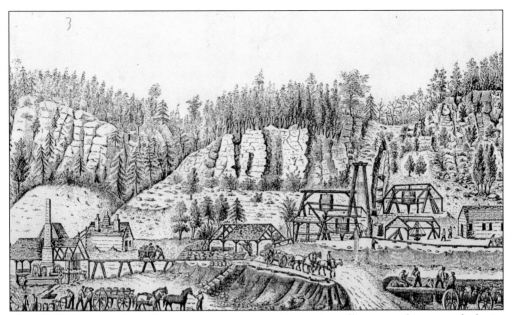

The Cliff Mine was the only mass native copper mine to actually turn a decent profit for its investors in these early years. This was due in part to the fact that there were plentiful and large masses of native copper, but also that rock could be worked with a stamp mill, which allowed for higher production. These tripod-like stands, named whims, were used to raise and lower ore buckets, called kibbles, with horse power. (Foster and Whitley, 1850 report.)

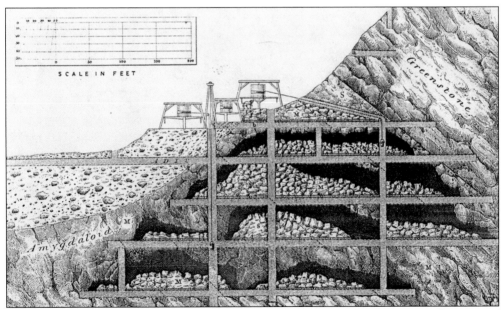

As the cliff developed its ability to deal with ore-based rock, it moved from its original concept of whims and kibbles to an adit, or tunnel into the side of the cliff, instead of vertical shafts. The adit allowed for easier removal of the ore in tram cars. (Cliff Mining Company annual report, 1862.)

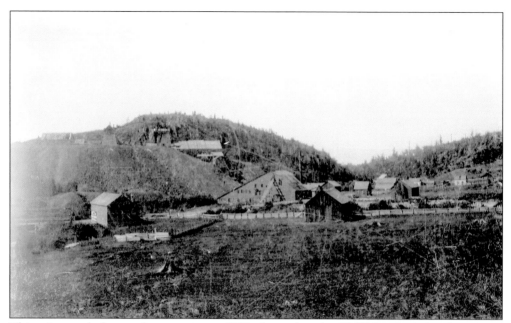

This print, made from a glass negative in 1890, shows that the Cliff Mine had already come to a standstill and that the town of Clifton was rapidly becoming a ghost town. The old gravity stamp mill still stands, but the shaft house is falling apart. While the Cliff Mine was one of the most profitable of the early mass mines, it also proved that mining mass native copper would not be the path to profits in the future.

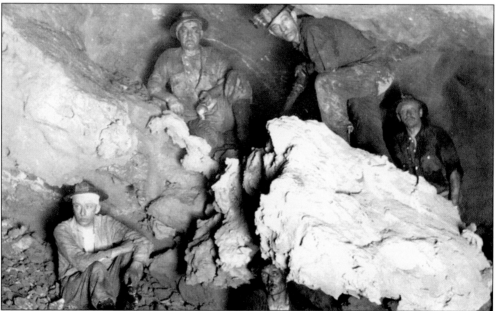

Weighing in at about 16 tons, copper is being extracted through the only means available for most of the boom: the chisel and hammer. This mass was found in the Quincy Mine in 1925. The only difference from past years is that these chisels are pneumatically, rather than manually, powered. When extracting mass copper in the days of the early Quincy or other mass mines, miners worked in teams of three, with two hammering and one holding the chisel.

Three

THE CALUMET
AND HECLA
A RED JACKET MIRACLE

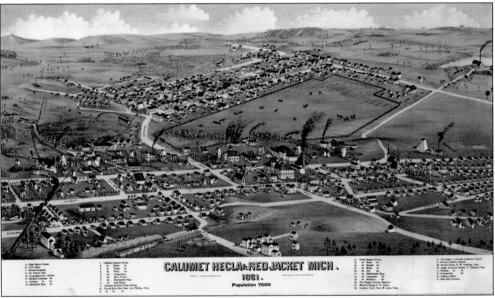

In 1864, Edwin J. Hulbert, a local surveyor and civil engineer, discovered the Calumet Conglomerate Lode. The local story goes that he found a prehistoric American Indian copper site while hunting for a friend's stray pig. The lode, 35 miles long, was the greatest find in the region. Hulbert formed two different mining companies to exploit the lode: the Calumet and the Hecla. In the late 1860s, under the leadership of president Quincy Shaw and local superintendent Alexander Agassiz, the two companies joined. Agassiz got the Calumet and Hecla (C&H) on track, and by 1869 the company had paid its first dividend of $100,000. When Agassiz took over, he realized that in order to make the mines profitable, ore needed to be processed and smelted near a large body of water. He chose the Lake Linden and Hubbell area on Torch Lake and constructed the first mining railroad in the region in the late 1860s. The narrow-gauge railroad was used to move ore from the mines to the mill and smelter on Torch Lake. By 1881, when this map was created, the town of Calumet had grown, as had the mines supporting it. (Map by J. J. Stoner, Madison, Wisconsin.)

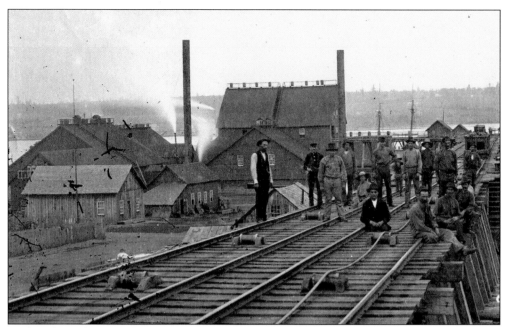

At first, the Calumet and Hecla Mine Railroad served an incline tram line, pictured here. By the 1880s, the Hecla and Torch Lake Railroad, as it was called when completed, carried ore down to the mill and coal back up to the mines in Calumet and elsewhere. (Photograph by A. F. Isler, Lake Linden.)

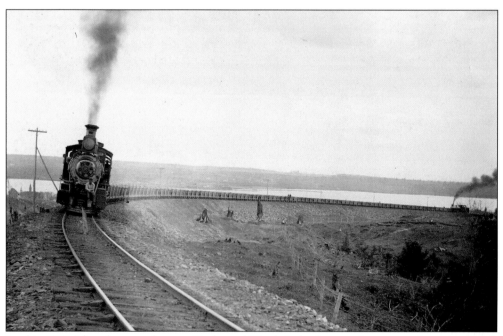

In this 1890 Isler photograph, two Hecla and Torch Lake locomotives move four-wheel rock "jimmies" up the grade from Lake Linden to Calumet, loaded with coal for the mine operations there. (Photograph by A. F. Isler, Lake Linden.)

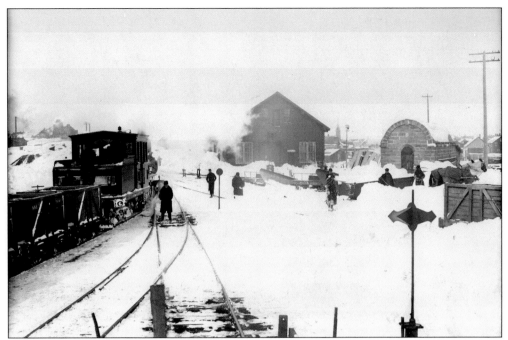

Overcoming the harsh winters in Copper Country was a major feat for the mining companies. Here, a Mason bogie locomotive pulls a string of rock jimmies toward the mine shafts, seen in the distance on the left. (Photograph by A. F. Isler, Lake Linden.)

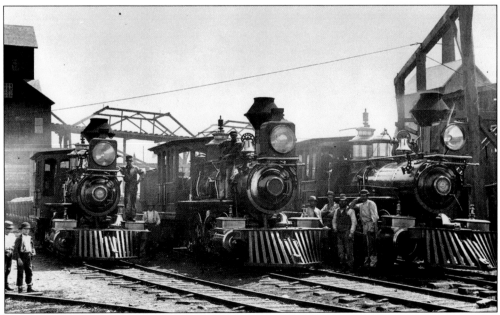

The Calumet and Hecla chose locomotives for its railroad from the Mason Locomotive Works, a firm in Taunton, Massachusetts. These Mason "bogies" were so called because the weight of the firebox was supported on a bogie truck, on which the frame of the locomotive pivoted. They were some of the most powerful and advanced of their day. These three look like they just arrived from the factory. (John Campbell Collection.)

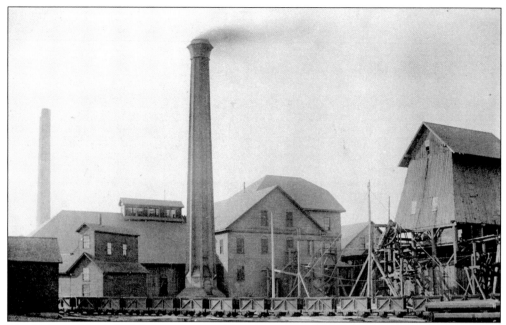

The Calumet No. 1 shaft house is pictured here around 1880. The structures to the left are the powerhouse and hoist house, as well as various shops for the support of the shaft. The shaft house was completely fabricated of wood, as it was the cheapest material and, up until the 1880s, the most available. Note the beautiful fluted brick stack. One of these stacks still stands today in Calumet. (Acton Company, publisher.)

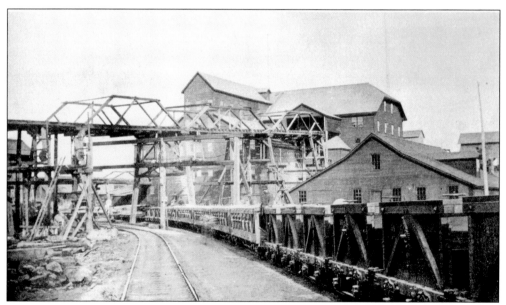

In the 1870s and 1880s, the mine shaft houses and rock houses of the C&H were predominately built of wood, as shown in this photograph of the No. 2 rock house. Shaft houses were connected via tram line, seen bridging the railroad below, to the rock house, which contained machinery used to sort, break, and crush the rock into forms usable by the mills and smelters in Lake Linden and Hubbell. (Acton Company, publisher.)

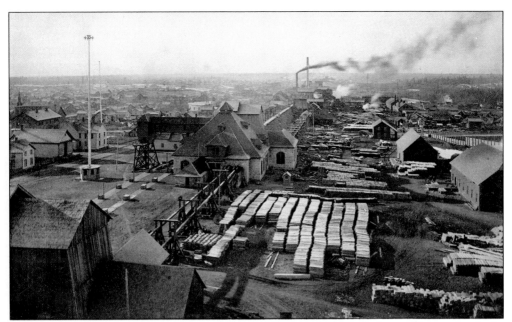

In this northward view from the smokestack of the Calumet No. 1 shaft powerhouse, the shafts follow the line of the ore body. The No. 2 rock house appears in the distance, near the site of the stack spewing smoke. The large structure of stone in the middle foreground is a pump house. (Photograph by A. F. Isler, Lake Linden.)

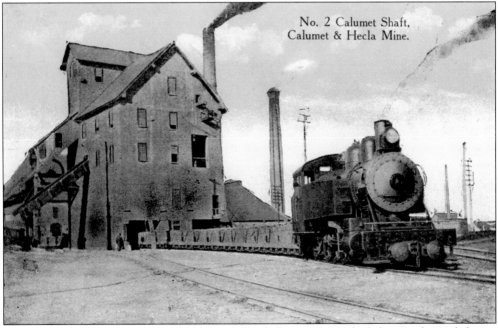

In this early-20th-century postcard view of the Calumet No. 2 shaft house, the rock house function has been moved to the corrugated-steel-sheathed shaft and rock house, and the ore cars are loaded directly at the shaft. The locomotive is the *Penoke*, a Baldwin tank engine. (Postcard by Yellow Front Curio Stores, Houghton.)

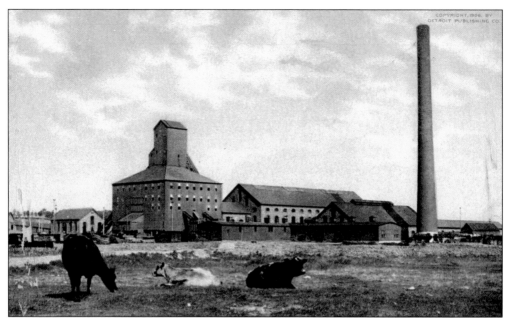

The Red Jacket shaft and rock house complex was opened in 1900. Built over a shaft opened earlier by the C&H, it represented the state-of-the-art. The shaft reached a depth of over 8,000 feet and was the predominant feature on the skyline of the Calumet area. It became, as this postcard view reflects, a major attraction for visitors. (Postcard by E. C. Kropp, Milwaukee.)

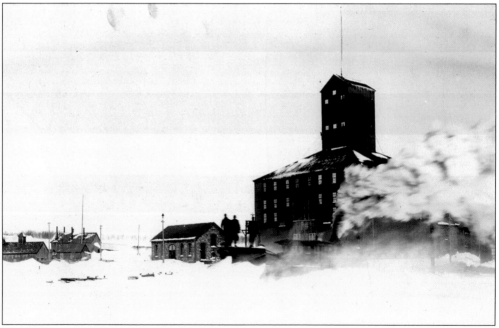

The Red Jacket shaft stands out in stark contrast to the snow, which virtually envelopes a Hecla and Torch Lake locomotive and plow struggling to keep open the loading tracks to the shaft house. Men ride atop the flanger plow and control the blade angles. (Photograph by A. F. Isler, Lake Linden.)

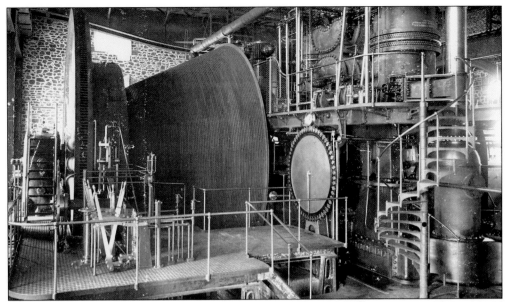

With hoisting engines like this one at the C&H-owned Seneca Mine, the hoist operator would control the up and down movement of the skip car with the levers seen at left. The skip car was used to carry men, materials, and ore into and out of the mines. The operator could tell what level the car was on by watching the large clock-like device at right. The tapered drum in the background carried the cable that was attached to the skips. Miners could tell the operator to move the car by electrical bell signals from below.

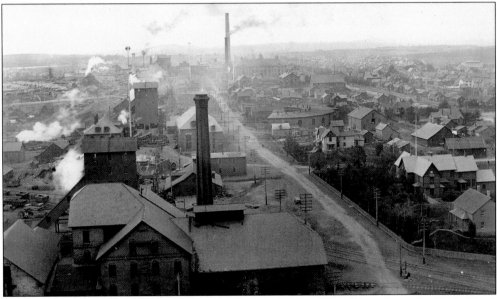

In this c. 1890 view of Calumet, the camera looks north on Mine Street from the Hecla No. 1 shaft toward the tall stack of the Red Jacket shaft hoist power house in the far distance. Between the camera and Red Jacket Shaft, front to back, are the No. 2 Hecla powerhouse with it's unique fluted brick smoke stack, the Hecla No. 2 shaft (left), the Superior pump house, and the Hecla No. 3 shaft. On the east (right) side of Mine street is the Hecla & Torch Lake Railroad roundhouse, the mine offices, and the Washington School. (Photograph by A. F. Isler, Lake Linden.)

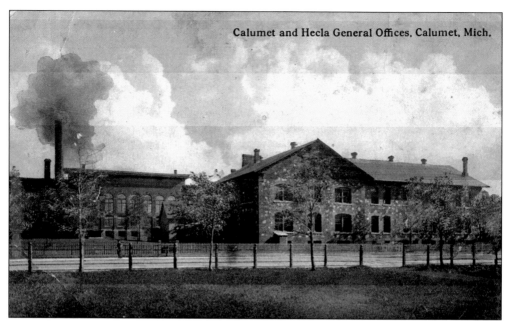

Calumet and Hecla General Offices, Calumet, Mich.

By the beginning of the 20th century, the C&H had invested in new technology, deeper and more efficient mines, and more elegant mine offices and brick schools for the sons and daughters of mine workers. This postcard view shows the new Washington School, serving kindergarten to 12th grade, and the expanded stone and brick mine office building. The latter now houses the offices of the Keweenaw National Historical Park. (Postcard by E. C. Kropp, Milwaukee.)

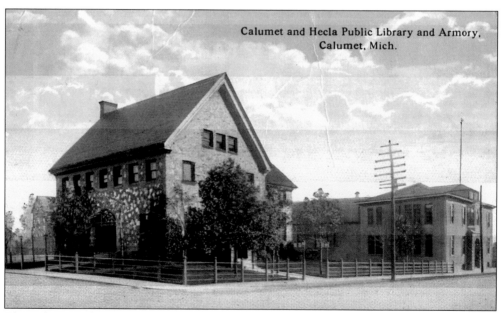

Calumet and Hecla Public Library and Armory, Calumet, Mich.

The Calumet and Hecla, like most mines in the area, provided housing, educational institutions, and medical care for its workers. A perfect example is the beautiful stone and brick library across the street from the mine offices. The structure, finished on the interior with beautiful woodwork, now houses the archives of the Keweenaw National Historical Park. (Postcard by E. C. Kropp, Milwaukee.)

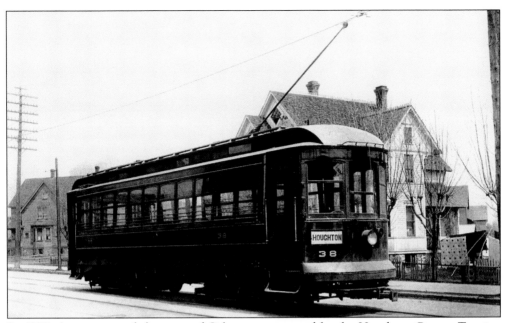

By 1900, the county and the town of Calumet were served by the Houghton County Traction Company. Here, car 38 passes mine management company homes along what is now U.S. 41. The company operated short four-wheel cars for city routes and these inter-urban trolley cars until the Depression and the automobile contributed to the line closing just before World War II.

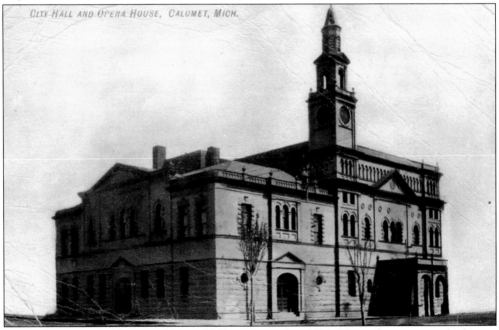

CITY HALL AND OPERA HOUSE, CALUMET, MICH.

The Calumet Opera House and Town Hall was opened in 1901. The auditorium was the largest in the upper lakes region for years. Performers of national renown, such as Sarah Bernhardt, made it a stop on their itineraries. This wonderful structure, located on Elm and Sixth Streets, is on the National Register of Historic Places and still functions today as it has since its opening. The steeple on the clock tower was destroyed, however. (Postcard by the Anderson Company.)

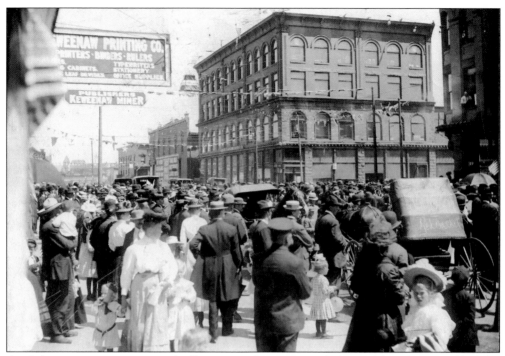

As Calumet grew in stature and affluence in the region and the world, it drew in all of the trappings of 19th-century success. Here, a crowd awaits the arrival of none other than Teddy Roosevelt on a campaign visit. In the distance is the Jacobsville-sandstone Vertin's department store, with its elegant arched show windows and four floors of merchandise.

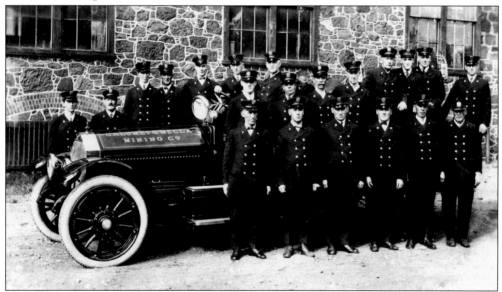

The C&H maintained a first-class safety program for its workers, which helped in very few accidents underground or on the surface compared to other operations of the time. It also maintained its own fire department, which maintained the latest equipment for fighting fire. As this 1925 photograph shows, this department also assisted the Calumet fire department when called upon.

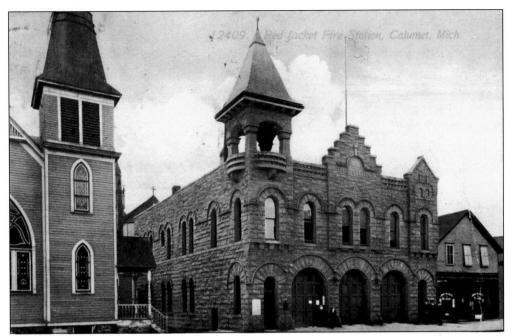

The Calumet City Fire Hall, once known as the Red Jacket Fire Station, which now houses the Upper Peninsula Firefighters Museum, was one of the crown jewels of the city in the heyday of the C&H. Built of Jacobsville sandstone, it showcases unusual Victorian Gothic architecture. (Postcard by W. F. Forester, Calumet.)

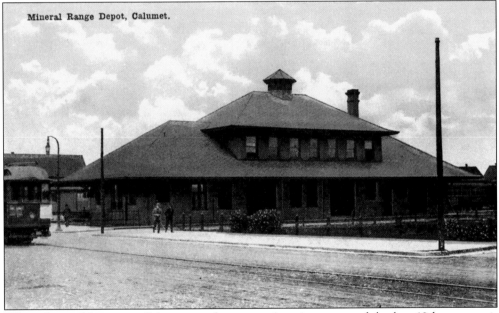

When the world came to Calumet, or almost any American town of the late 19th century, it came by train. The Calumet Union Station, originally built by the Mineral Range Railroad, was the primary of the two stations in town. It was also served by the Houghton County Traction Company. The other depot was built by the Copper Range Railroad and was located on Pine Street. (Postcard by W. F. Forester, Calumet.)

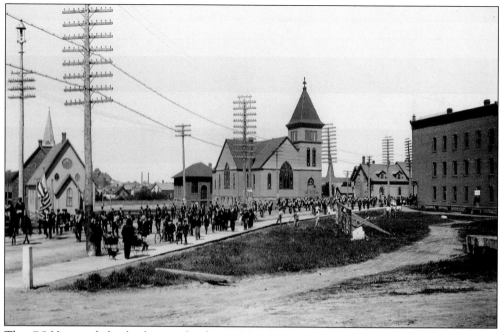

The C&H provided subsidies in the form of land and building material grants to churches needing a leg up in organizing. The paternalistic labor management of the late 19th century aimed to give workers and their families outlets other than bars and brothels. In this image are five land-granted churches.

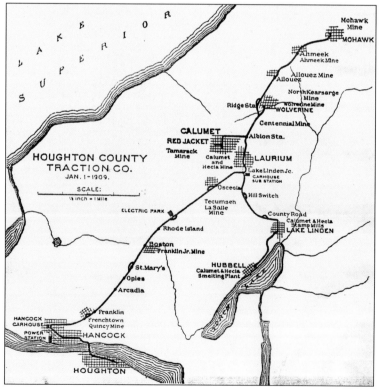

This 1909 Houghton County Traction Company map shows routes in the heyday of the system. The line traveled to Electric Park, a recreational facility for area residents. In many areas like Houghton, electric companies and trolley lines had common ownership. The powerhouse for the line also produced lighting for the city. In addition, it was a regular practice for trolley companies to build electric parks as a destination on the line.

Four

OLD RELIABLE
THE QUINCY MINE

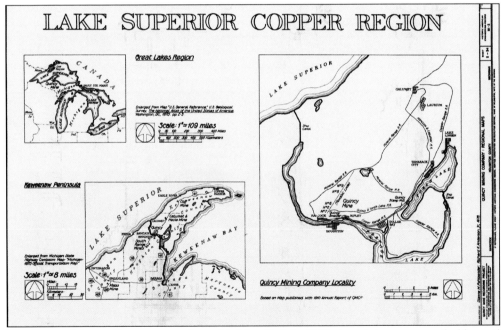

The Quincy Mining Company was formed in New York in 1848, though it was not profitable until 1856, when the Pewabic Amygdaloid Lode was discovered by the Pewabic Mining Company. The Quincy, Pewabic, and Franklin Mines all tapped the Pewabic Lode, but through careful claim management—along with good luck—the Quincy enjoyed both the largest amount and the richest part of the ore body. The above map shows the location of the Quincy through its life as a mine and its geographical location in Michigan's Upper Peninsula. The Quincy rapidly became the second most profitable mine in the district. In 1862, it became the first mine on the Pewabic Lode to pay its stockholders a dividend. The operation produced dividends for its stockholders so regularly and for so long that it was dubbed "Old Reliable." (Map by the Historical American Engineering Record, U.S. Department of the Interior, 1978.)

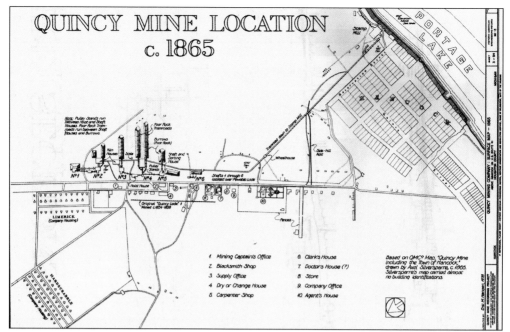

This drawing, produced in 1978 for the Historical American Engineering Record, U.S. Department of the Interior, shows how the entire system of shafts, hoists, and rock houses related to each other. Please note that actual photographs of the early Quincy operations in the 1860s are also featured on pages 55 and 56.

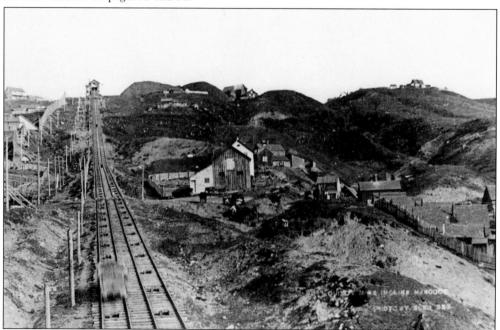

The Quincy incline fed the old stamp mill on Portage Lake until 1890, when new facilities were opened on Torch Lake. This 1885 action photograph by Isler shows a rock car descending the tram road in Hancock. Far above, another tram car approaches the wheelhouse for reloading. (Photograph by A. F. Isler, Lake Linden.)

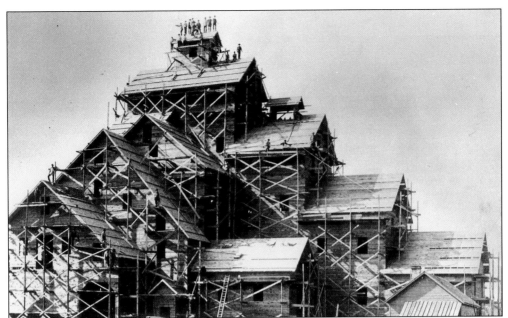

Around 1890, changes in mining operations were reflected in the new, larger, and more efficient shaft and rock houses. This 1892 photograph reveals the construction of the No. 6 shaft and rock house, known locally as the House of Many Gables. The building featured its own steam engine with crushers and both a steam and drop hammer used for dealing with mass copper and pieces too large for the stamp mills.

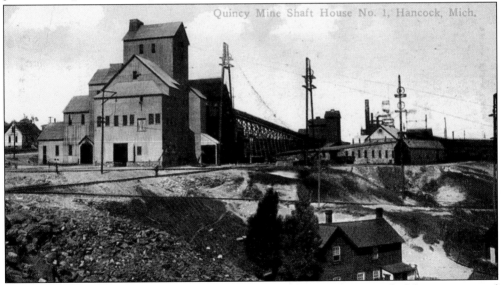

This improperly labeled postcard view, taken around 1900, shows the No. 7 shaft house connected by a tram road to the old No. 4 shaft and rock house. Below and to the right of the tram road is the roundhouse and machine shop for the company's 36-inch-gauge railroad, the Quincy and Torch Lake Railroad. In the far distance is the top of the brand-new No. 2 shaft house, completed in 1908. By this time, the Quincy was working four shafts in addition to the six former Pewabic shafts. Some were not actually worked but used as air shafts. By the 1920s, the Quincy had descended to more than 9,000 feet below the surface. (Postcard by Yellow Front Curio Stores, Houghton.)

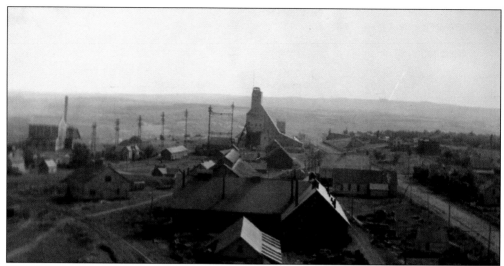

The Quincy No. 2 shaft is to this day both a landmark and symbol of the copper mining history of the Keweenaw Peninsula. The No. 2, the culmination of shaft and rock house design, replaced an earlier wooden structure built in 1894–1895 that simply was not up to the job. Because of the efficiency of the design, as few as three men could handle upwards of 1,000 tons of rock in 12 hours. The shaft can be still be toured today as part of the Keweenaw National Historical Park.

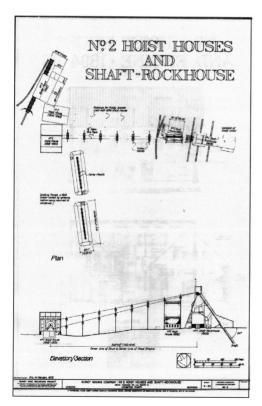

This drawing from the Historical American Engineering Record illustrates the relationship between the mine hoist and the shaft and rock house. It also shows the various locations of the earlier hoist houses of 1882, 1894–1895, and 1920. Tours of the 1920 hoist are available today at the Quincy unit of the Keweenaw National Historical Park.

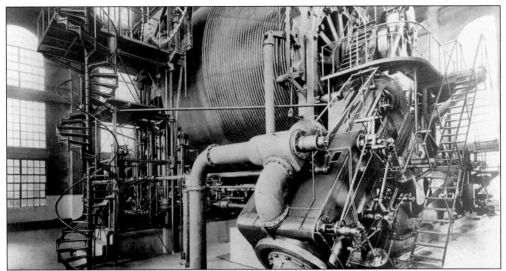

The Quincy No. 2 mine hoist was also a record-setting piece of equipment. When the new No. 2 was opened in 1908, it operated with the hoisting engine that had supported the old 1895 shaft and rock house. With the mine going ever deeper, it became clear to management that new equipment was required. Nordberg Manufacturing of Milwaukee, Wisconsin, provided a solution by manufacturing the world's largest compound condensing steam hoist for the Quincy in the 1920s. Unfortunately, the Great Depression sunk the price of copper (and the mine with it). The Quincy never realized a proper return on its investment. (Photograph by Nordberg Manufacturing Company, Milwaukee.)

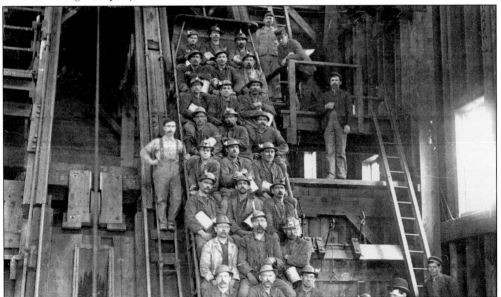

Miners at shift change are transported in a man car in the No. 6 shaft. As the mine grew deeper, temperatures below ground approached 100 degrees. Miners would speed down the shaft at 35 miles per hour with a lunch pail, leather safety hat with attached sunshine lamp to light their way underground, and the same set of clothes they had hung in the steam-heated dry the day before. The ceiling of the skip shaft was only inches above their heads, leaving little room for movement once the man car was in motion. (Photograph by A. F. Isler, Lake Linden.)

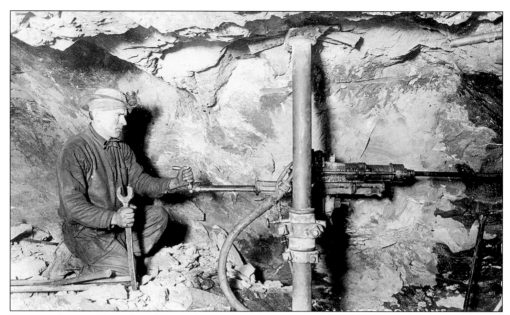

Once underground, workers began their tasks. This miner drills with a one-man Ingersoll-Rand compressed air drill. After completing a pattern of holes, he would pack them with dynamite and blasting caps and "blast the face." Then muckers and trammers would follow his work and clear out, or "muck out," the rock. The trammers would haul it away using hand-pushed, and later electric, tram cars. This photograph dates to the early 1900s, when carbide head lamps became the preferred underground light source over tallow lamps or candles. (Postcard by W. H. Forester, Calumet.)

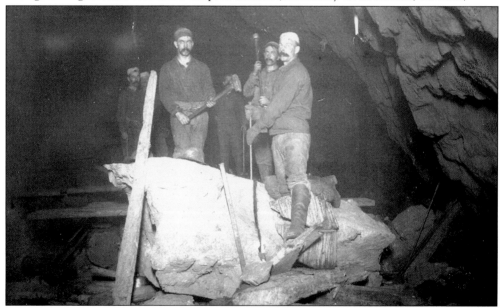

A team of miners works on a large mass of almost pure native mass copper. After removal from the surrounding rock with chisels and pry bars, the pure native masses were worked underground. In the case of large masses like this one, the only way to remove this product was to cut it into manageable pieces. The crew will work for as long as two to three days on this piece to reduce its size so that it can be moved and brought by special tram car to the shaft for transport to the surface.

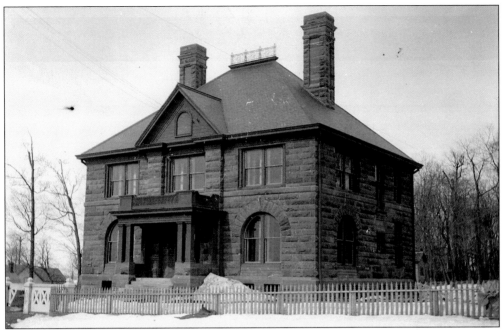

The Quincy Mine was one of the two leading companies in the Keweenaw's mining industry. The company, in keeping with its image, built a mine office befitting its place and sense of permanence in the copper region. This beautiful Victorian structure of Jacobsville red sandstone speaks of quality, reliability, and also of the higher status of the managers within its walls.

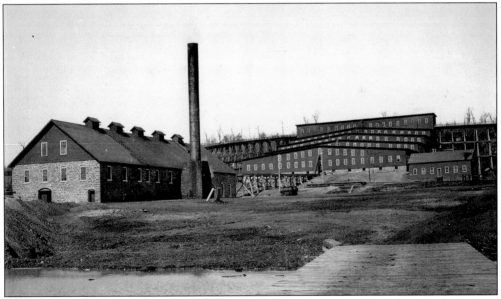

Quincy stamp mill No. 1 was opened on the southwest shore of Torch Lake and a milling community established there. Homes were built for mill workers, and the community was named Mason for Thomas F. Mason, president of the New York based firm. The supply of cordwood for the steam boilers that originally powered the mill equipment was rapidly exhausted. By the beginning of the 20th century, coal was brought in by ship down the Portage Lake and up the ship canal directly to Mason on Torch Lake. A second, smaller mill, No. 2, was built in 1900.

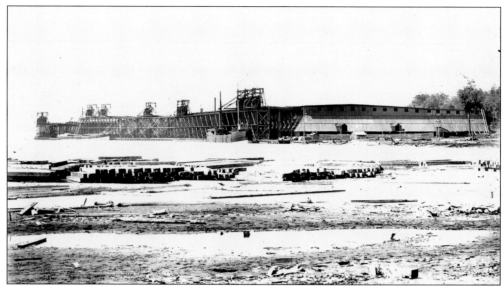

Mason's coal docks and shed were opened in 1903 directly across from the No. 1 stamp mill on what is now Michigan State Highway 26. The docks featured the most modern Hullett ship unloaders available at the time. The extensive system over the coal piles was constructed of corrugated sheet metal and timber, which allowed the coal to stay dry through the long and snowy Keweenaw winters. Coal was hauled from Mason to the top of the Quincy ridge by the Quincy and Torch Lake Railroad, or to the smelter at Ripley by the Mineral Range Railroad. (Photograph by A. F. Isler, Lake Linden.)

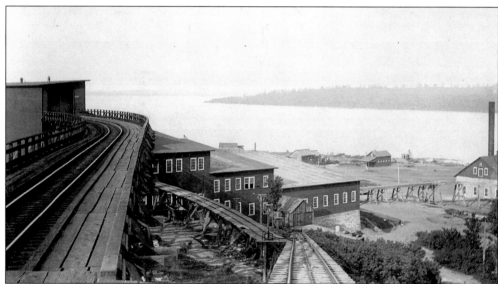

This c. 1892 view of the Quincy No. 1 mill looks toward Torch Lake from the Quincy and Torch Lake Railroad tracks. The tracks here are elevated to allow the ore hoppers to dump their loads into bunkers above the stamp mill engines. The milling process had one objective: to liberate copper from the surrounding waste rock. The Allis Stamp Mill engines crushed the rock to fine sand, which was then carried by water to the rest of the mill as a slurry of ore, copper, and water. The waste rock from the process, a fine sand, was simply washed into the lake. (Photograph by A. F. Isler, Lake Linden.)

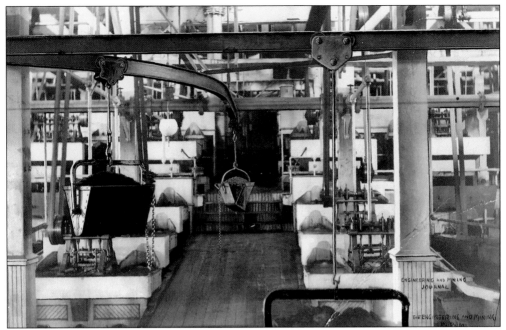

Using various devices, workers sorted the ore by size. The mills used mechanisms such as the jigs pictured here. Jigs worked much like early washing machine agitators, creating a hydraulic current that caused the ore to separate by density. This process, which was typical of mills throughout the region, would yield about 30 pounds of copper for every ton of rock stamped.

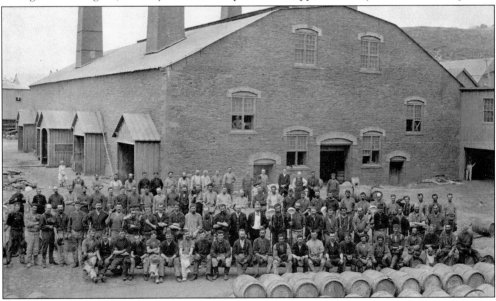

Once the ore was stamped and the copper extracted, the copper concentrates were sent by train to the smelter for forming into slabs, ingots, or various other shapes. In the early days, the native copper masses and concentrates were shipped out of the area for processing. This began to change when smelters were built in Hancock and later, west of Houghton. The smelter crew shown above stands outside the No. 5 reverberatory furnace building of the Quincy Smelter around 1908. (Photograph by A. F. Isler, Lake Linden.)

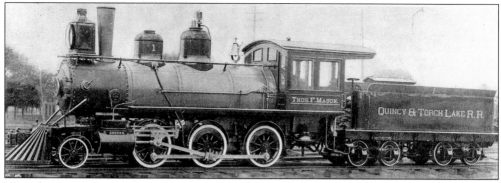

The *Thomas F. Mason* was the first Quincy and Torch Lake Railroad 36-inch-gauge locomotive purchased by the mining company. Built by the Brooks Locomotive Works, it pulled strings of wooden rock cars up to Quincy and down to Mason daily. (Quincy Mine Hoist Association, Michigan Technological University Archives and Copper Country Historical Collections, Michigan Technological University.)

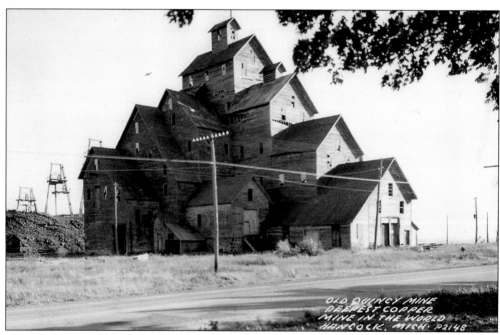

The old House of Many Gables, the No. 6 shaft house of the Quincy Mine, burned in the mid-1950s at the hands of vandals after being inactive since the 1930s. Even in its derelict state, it had a structural beauty that became a unique trademark of the region. The shaft below No. 6 was a mile deep.

Five

HOUGHTON AND HANCOCK

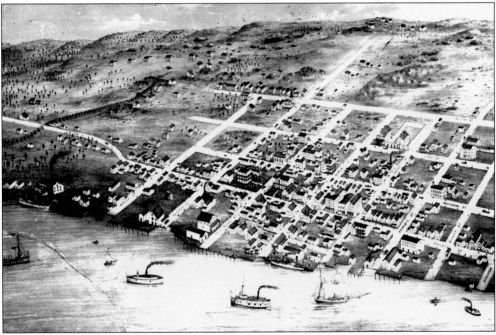

In 1859, Houghton was a mere village of about 600. Located on the shore of Portage Lake, the town was dependent on whatever could be shipped in during the six months of shipping that Lake Superior would allow. The founding of Houghton is credited to Ransom Shelden, who along with C. C. Douglass and Capt. Richard Edwards, incorporated the village in 1857. This map from 1872 shows the rapid growth that occurred after the Civil War, when capital from the war boom and the high demand for copper for power and telephone wiring fueled the development of the city. The right side of this map shows the location of the Shelden and Columbia Mines, founded by Ransom Shelden and his sons, and the tramway that traveled down to the stamp mill on Portage Lake. Also shown is the steamer *Ivanhoe* at the Louis Hennes dock. (Map by J. J. Stoner, Madison, Wisconsin.)

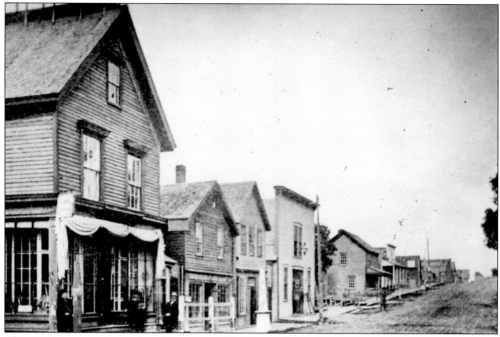

This 1860s stereoptical view focuses on Shelden and Shafer Drugs, built in 1852. The first commercial building constructed in Houghton, it was owned by Ransom Shelden and his son Ransom B. Shelden. (Keystone-Mast Collection.)

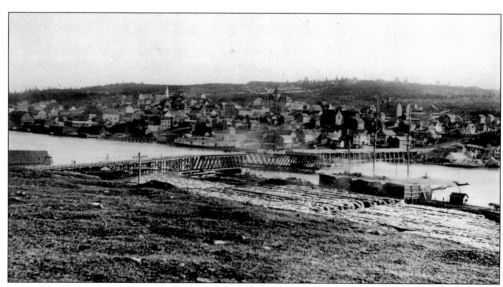

In this 1880 Acton Company view across the Portage Canal, the first combined traffic swing bridge connects Houghton with Hancock. The bridge replaced a much earlier single-level drawbridge and a ferry service that operated until ice-up, after which sleds were used for crossing. Due to irregular ice conditions, this could be quite risky at times. (Acton Company, publisher.)

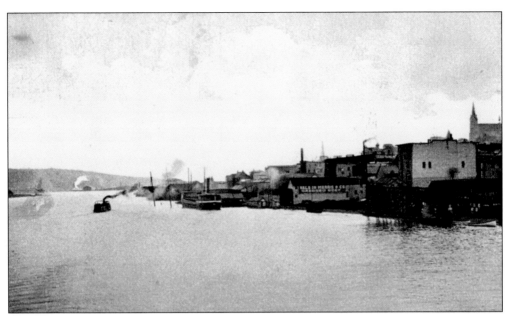

This early postcard view, retouched from an earlier glass plate, reveals one of the Hancock-Houghton ferries that operated until the end of the 19th century. The Houghton Company Transit trolley cars and the early automobile finally spelled the end for the ferry boats. This image shows the shoreline docks and, on the far right, the spire of the new St. Ignatius Loyola Church, completed in 1907.

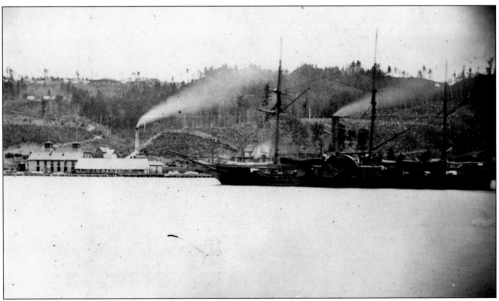

During its earliest years, the Houghton-Hancock area, as well as the whole Keweenaw Peninsula, was dependent for the essentials of life on mail/packet ships such as this paddlewheel steamer. Houghton was primarily a port city; not until the arrival of the Marquette, Houghton, and Ontonagon Railroad in the mid-1880s could trains bring freight to the region.

The *Portage Lake Mining Gazette*, a paper of "quarto form, 6 columns to the page" was established in June 1859 by J. R. Devereaux, proprietor and editor. In 1870, the paper changed to the folio form it continues today. The text focused on both mining interests and general news of the county.

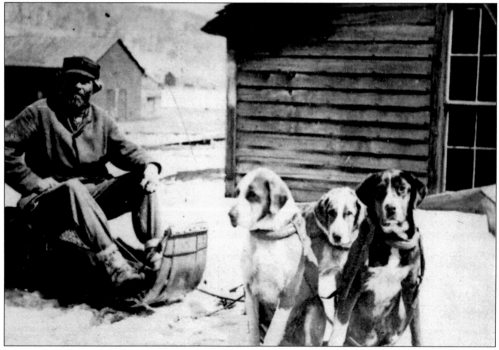

This man, along with his trusty dogs and toboggan, made sure that mail was distributed to the remote settlements far from Houghton in the early years of the Copper Country.

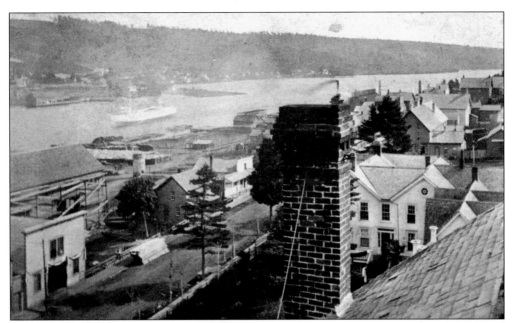

These stere-optical images of Houghton show that by the year 1880, the area had developed from a settlement of a few log cabins and clapboard stores into a burgeoning city. This view looks east toward Portage Entry (South Entry) and Chassell. A paddlewheel packet steamer, likely the *Ivanhoe*, is inbound to the docks on Portage Lake. The *Ivanhoe* made regular trips to L'Anse and Marquette. (Keystone-Mast Collection.)

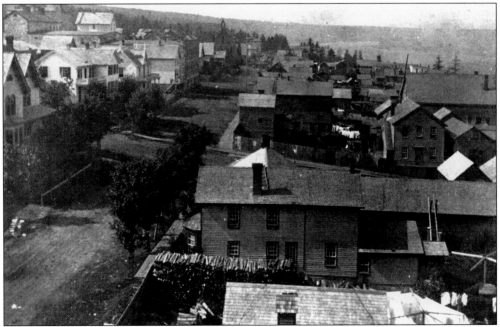

The photographer of this companion view faces west toward where the Portage Lake swing bridge crossed the lake. A wooden swing bridge was first installed by the Portage Lake Bridge Company in April 1876. The company also owned the tug *Lizzie Sutton*, which made trips between Houghton and Hancock every half hour at a cost of 5¢ each way. (Keystone-Mast Collection.)

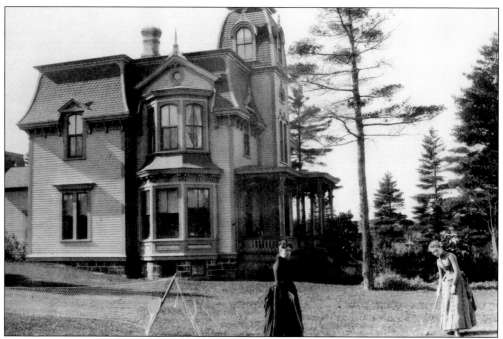

The Shelden family, the first family of both the county and the city of Houghton, prospered in various ways. George C. Shelden, the third son of pioneer Ransom Shelden, was the president of the Portage Bridge Company and owner of a brewery and warehouses in Houghton. The G. C. Shelden home, overlooking the Portage and Hancock from high on the hill, was the perfect example of Victorian style. (Acton Company, publisher.)

Carlos D. Shelden, manager of the Portage Lake Foundry and Machine Works, made his fortune building heavy equipment for the growing mining industry in the surrounding district. He also had iron mining interests in the Menominee iron range. His home is pictured here.

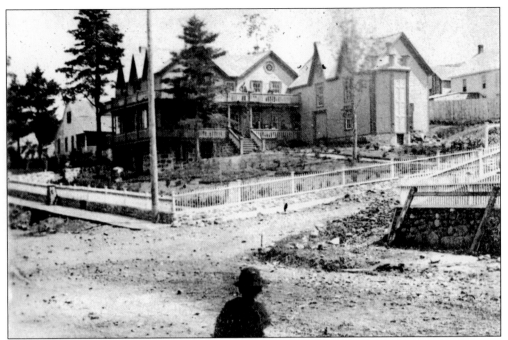

Both Houghton County pioneer Ransom Shelden and his youngest son and namesake, Ransom B. Shelden, occupied this original homestead. As was sometimes typical of original settlers' homes, they grew to odd proportions as they prospered. The home was reported to have 12 bedrooms and numerous other rooms, as well as an attached barn, which was typical of the Victorian age. The building, facing what is now Shelden Avenue, housed the first offices of the First National Bank of Houghton.

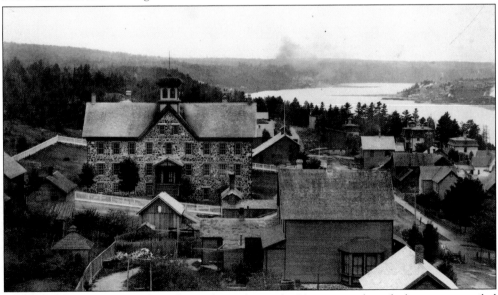

From the very founding of the village of Houghton, the Victorian value of education prevailed as the key to success. The Houghton Union School, known as the Rock School, was built in 1873. It was one of the earliest permanent non-mine stone structures in the area, and was the pride of the community.

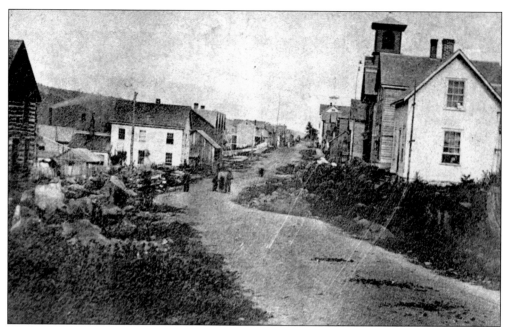

Civil War revenues from copper production brought about rapid changes in Houghton during and just after the war, when this photograph of Shelden Avenue was taken. In this eastward view toward the village center, the home on the left is that of founder Ransom Shelden. (Keystone-Mast Collection.)

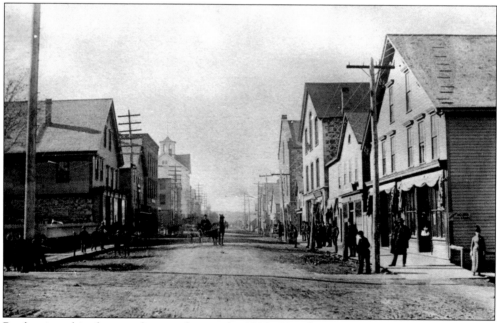

By the time this photograph was taken in the 1880s, Houghton was rapidly becoming a city of significant proportions. Telephone lines and an increasing number of solid brick and red Jacobsville sandstone buildings hint at the vibrant growth of the city. The tower of the old Douglass House Hotel, named after first citizen C. C. Douglass, appears in the distance, on the left.

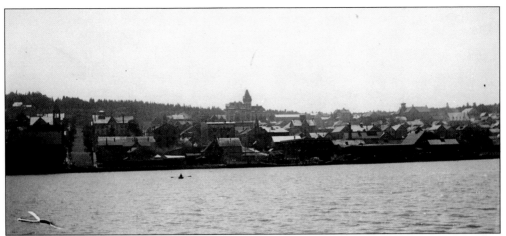

This view of Houghton from the Portage Lake reflects the density of Houghton at the end of the 19th century. Prominent in the center is the tower of the new Houghton County Courthouse, which replaced a two-story wood frame structure built as the county seat in the 1860s. To the left is the bell tower of the Houghton School, and to the right is the cupola of the old Douglass House Hotel.

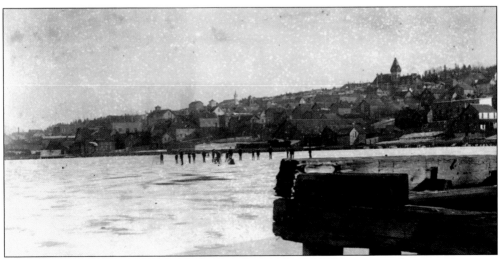

Professional ice hockey, which got its start in Houghton in 1903, was a popular sport in an area where winter dominated half of the year. In this photograph, men play on the ice of Portage Lake in the shadow of the county courthouse. As ice sports grew in the area, heavy snows and the inconsistent freeze of the lakes drove the construction of the Houghton Amphidrome, one of the first indoor hockey and ice-skating facilities in North America.

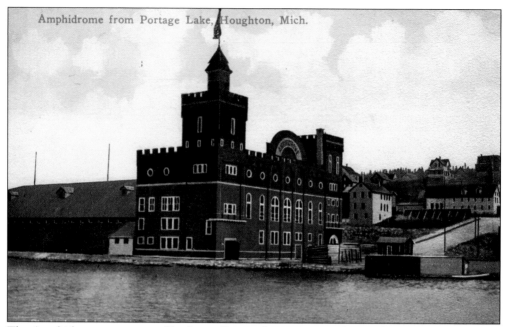

Amphidrome from Portage Lake, Houghton, Mich.

The Amphidrome, constructed by James Dee in the 1890s, was designed to support all types of indoor activities, in addition to skating and ice hockey. This early postcard shows its castle-like false front, which was removed in the early 1900s when the structure became known simply as the Dee Arena. (Postcard by W. H. Forester, Calumet.)

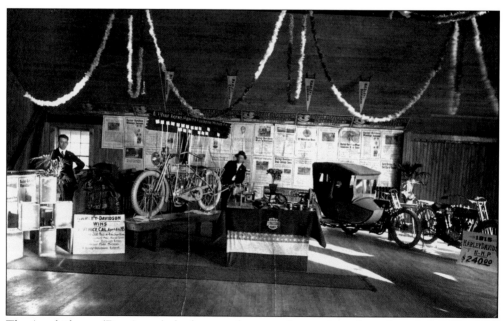

The Amphidrome (Dee Arena) also became the venue for a variety of social occasions. The 1898 Old Settlers Ball, which celebrated the original settlers of the region, was one such affair. Other events were trade shows, fairs, and even motor vehicle shows like the 1915 Harley Davidson show, pictured here. Those Harley Davidson pennants above the stand would constitute a king's ransom to collectors today!

48

Built in 1886, the Houghton County Courthouse is still a commanding structure on the skyline of Houghton. It was constructed in a Midwest version of the French Second Empire style, roofed with Lake Superior copper. The structure, which underwent significant restoration in 2003–2004, is listed in the National Register of Historic Places. (Acton Company, publisher.)

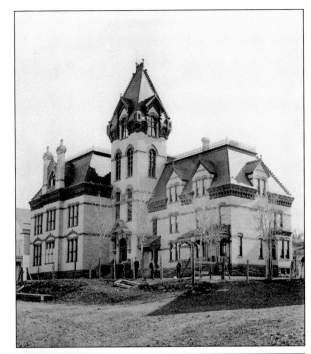

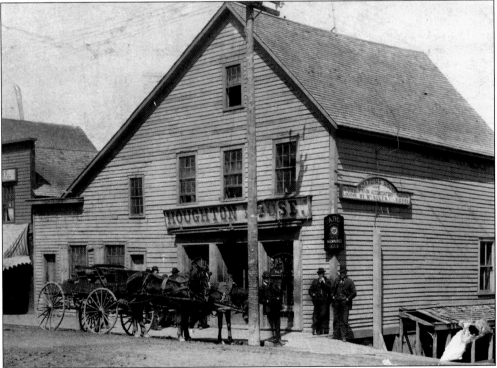

William Allen's Houghton House was one of the earliest hotels in the area. Like a modern motel, it provided for both the traveler and his horse and buggy. According to an 1887 advertisement, the Houghton House offered "fine wines, liquors, beer, and choice cigars." The establishment provided rooms by the day and by the week, including stabling for teams and rigs.

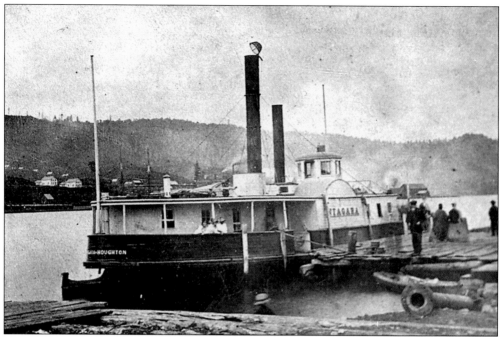

The old ferry *Niagara* provided a nice evening shuttle to the Kerridge Theatre on the Hancock side of the Portage. This view, from a very old stereopticon slide, shows the ferry in its livery around 1875.

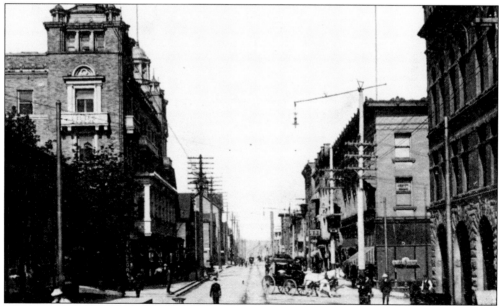

This postcard features an impressive view of the other end of the travel accommodation spectrum in late-19th-century Houghton—the Douglass House Hotel (left). Named for C. C. Douglass, a friend of Shelden and co-founder of the city, the new structure commanded a premier location adjacent to the prestigious Houghton Club, mostly out of sight to the left. Note the Houghton County Traction Company trolley car coming up the center of Shelden Avenue. (Photograph by O. F. Tyler, Calumet.)

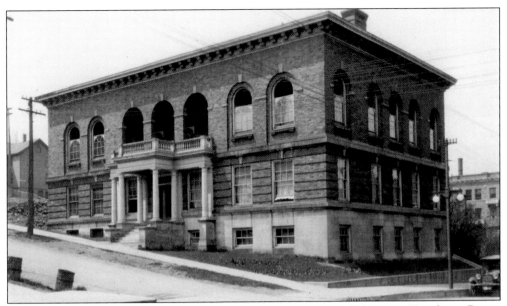

The Houghton Club fit well with the stratified patrician society of Victorian Houghton. Begun in the late 1890s, the structure shown here was built in Italianate revival style. It provided an upscale setting in which the copper barons could entertain guests, make deals, dine, use the athletic facilities, and generally enjoy themselves. The building is now occupied by U. P. Engineers and Architects.

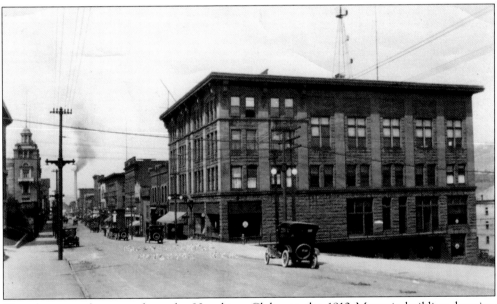

Directly across the street from the Houghton Club was the 1910 Masonic building, housing businesses on the lower floors and the Masonic temple on the upper floors. It is what remains of the finest Jacobsville sandstone structures in the city. Its stone (and that of many other buildings in the area) came from the quarries in Jacobsville, which were located on the north shore of the south Portage entry to the Houghton Ship Canal. Note the early rooftop radio antenna in this 1920s photograph.

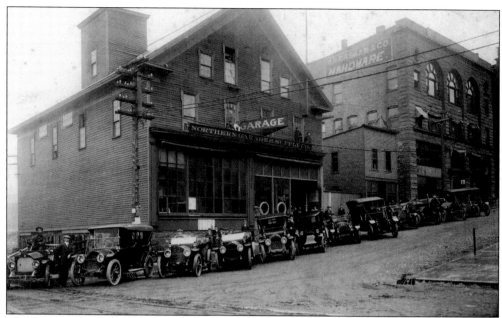

The automobile age, as illustrated in this 1915 image of Houghton, brought the need for frequent repair. The Northern Garage and Supply Company provided for all of the diverse auto parts needs in the city. This structure once stood at the foot of the hill on Isle Royale Street next to the red sandstone Daskam Hardware building, which later housed the *Daily Mining Gazette* until the 1960s.

This *c.* 1885 postcard view of the Isle Royale shaft houses shows the extent to which the workings of this mine had grown from its early beginnings in 1854. The Isle Royale, located on the east side of the Houghton ridge, was the first mine on the Portage Lake. It eventually sported its own railroad and surface plant. Unfortunately, by the time of this image, the mine was already in decline.

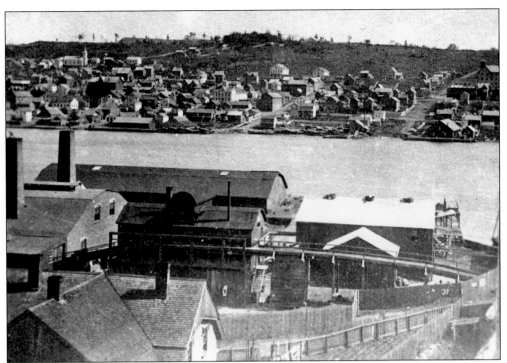

The Huron Mine (top center on ridge) was the other mine that overlooked the Houghton side of the Portage Lake. It, too, did not prosper much past the end of the 1890s. An old mine, the Huron first opened in 1855, closed, then reopened in the 1880s. It never developed into a significantly profitable operation.

In response to the growing need for professional managers, geologists, and engineers, the Michigan College of Mines was founded in 1885. During the first couple of years, classes were held on the second floor of the Columbia Fire Hall. When this photograph was taken around 1900, national acclaim and the mining companies' endowments had built what is today one of the nation's top 10 engineering schools.

Houghton

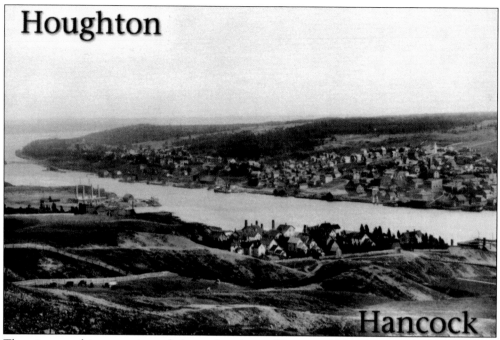

Hancock

The view on this souvenir card shows the close affiliation of Houghton and Hancock. The relationship does not dispel the fact, however, that both are fiercely independent communities. While Houghton was the preferred address of mine owners and managers, Hancock became a working-class bastion, claiming the largest Finnish community outside of Finland. Home to Finlandia University (formerly Suomi College), Hancock was the primary support community to the Quincy Mine.

The Quincy Mine sent rock to be milled and smelted to the shore of Portage Lake by means of a gravity tram, which terminated on the Hancock shore near what is now East Hancock and/or Ripley. In turn, Hancock climbed the ridge toward Quincy and its boarding houses up Tezcuco Street, pictured here in the 1870s.

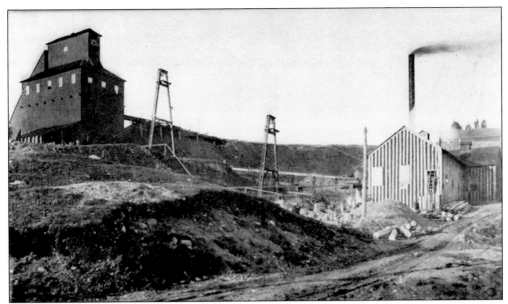

The Hancock Mine, sited immediately above the west end of the village, never achieved the high level of profitability that the Quincy, Franklin, and Pewabic Mines, located higher up the ridge, boasted. Founded in New York in 1859, the mine was reorganized in the winter of 1879–1880, but was later closed in 1885. The location is on the campus of Finlandia University (formerly Suomi College).

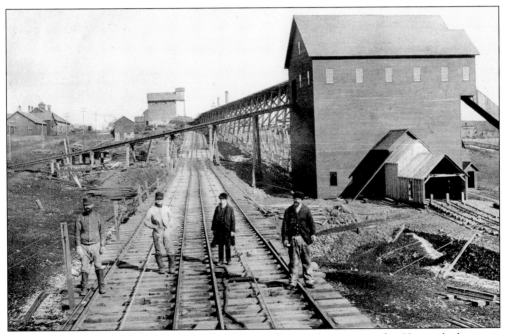

The early Quincy, Franklin, and Pewabic Mines all sent their ore to the Hancock shore via incline tramways like the one pictured here. After a load of heavy mine rock went down, the tramway would, with a little help from a steam engine at the top, pull up a load of firewood or coal for the mine to use in its steam engines and stoves. (Acton Company, publisher.)

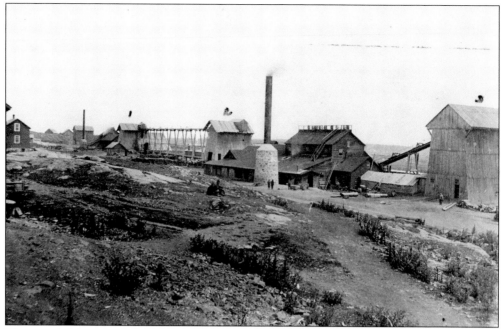

These rock houses and shaft houses (Quincy shaft Nos. 1, 2, and 3) are typical of the early workings on the Quincy Lode around 1870. The structures with the large stacks are housing shaft hoists, incline tram hoists, and pumps, all of which were steam powered.

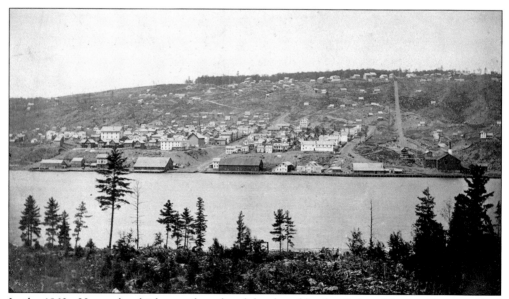

In the 1860s, Hancock, which was platted and developed by the Quincy Mining Company, had already grown to encompass the Detroit and Lake Superior Copper Company smelting works, seen here along the lake to the far right of the stamp mill, near the incline tram on the right. This 1868 image pre-dates the coming of the Mineral Range Railroad, and shows, from left to right along the water, the Moracee Sawmill, the warehouses of the Close Dock Company, and the Quincy Stamp Mill below the tram. Tezcuco Street is in the center and reservation to the right, curving toward the Quincy Mill.

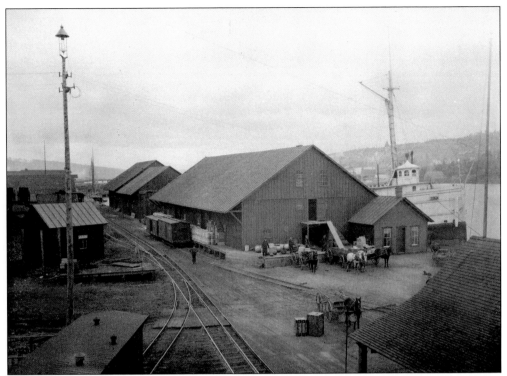

The Close docks and warehouses, which stood where the Houghton County Marina does today, was the point where the new Mineral Range narrow-gauge railroad would pick up goods for shipping to Calumet and points north. The dock was developed by James A Close, who was also a principal in the Sturgeon River Logging Company and the Hancock National Bank.

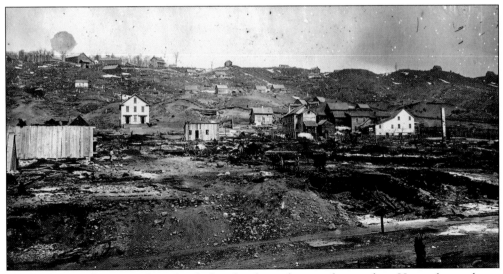

On Sunday, April 11, 1869, three days before the above photograph was taken, Hancock was almost totally destroyed by fire. This image, taken from a glass-plate negative, shows the terrible results.

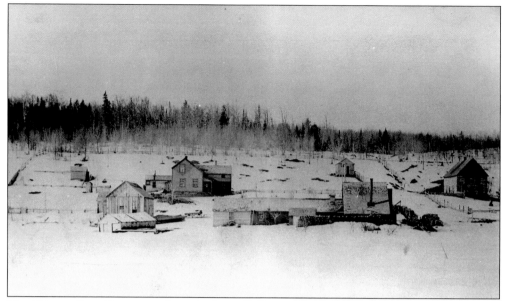

The Princes Fuse Company plant, built in 1867, supplied black powder fuse to the mining companies of the region. This photograph dates to 1874. In later years, the area on the Portage Lake in front of the plant would become a popular swimming beach called Princes Point.

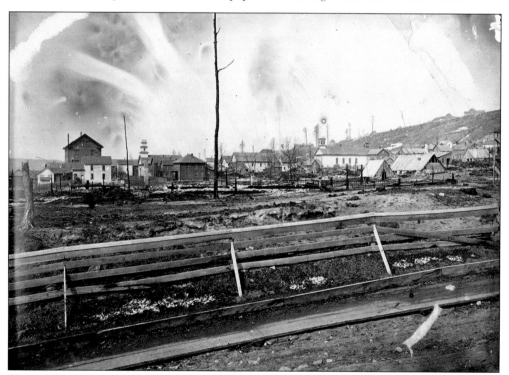

The mining companies encouraged families to attend church, which ensured that the mining boom in the Copper Country was nowhere near as lawless as the Gold Rush of 1849 in California. Here, two churches stand within a block of each other after the fire of 1869. Obviously, the parishioners (there was no fire department until 1871) put a priority on saving them!

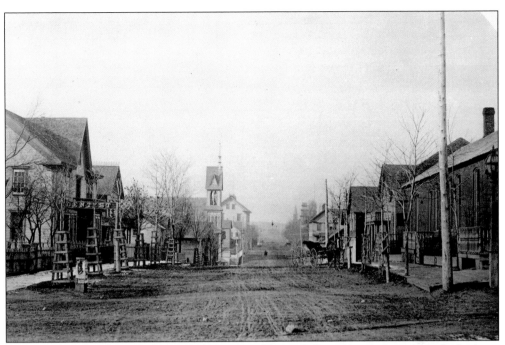

By 1876, when the photographer took this picture, Hancock Street was once again in the business of growth. New trees planted along the board sidewalks and new brick-and-frame structures have replaced the vacant lots caused by the 1869 fire. (Acton Company, publisher.)

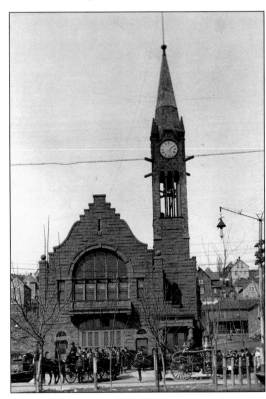

The Hancock City Hall and Fire Department on Quincy Street appears here around 1899. The structure includes a Neo-Gothic spire, briefly the fashion with architects of this period. The steam fire engine seen above is in front of the fire hall to the right.

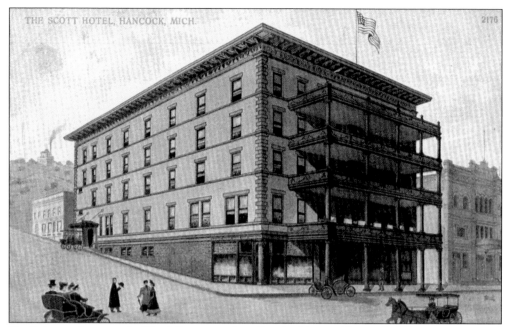

Until the modern era, the Hotel Scott was the tallest building in Hancock. When it was opened in the early 1900s, it was the epitome of modern hotels, boasting excellent banquet rooms, opulent suites, and a popular café, which became a mecca for breakfast and afternoon coffee. The Scott is currently being restored to it original grandeur. (Postcard by A. C. Bosselman and Company, New York.)

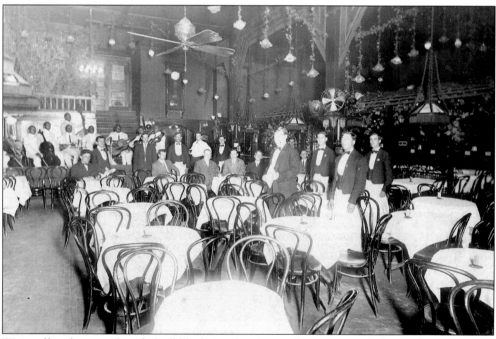

Waitstaff and an unidentified all-black jazz band pose for a portrait before a fancy event in the Scott grand dining salon in the early 1920s. You can almost hear the "Jelly Roll Blues" or the "Charleston."

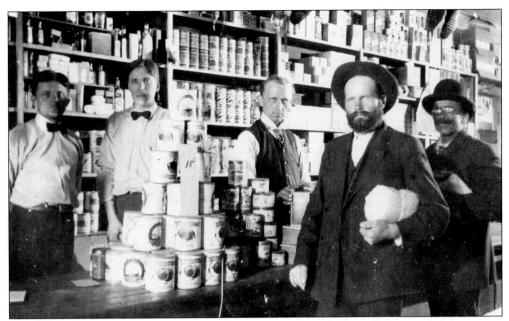

The Labor Commercial Store in Hancock was set up through the collaboration of the miners and their union affiliations (predominantly Western Federation of Miners) to provide workers with food and other needs at better prices. Here, miners pose at the front counter with the store staff. The co-op movement grew out of the increasing labor unrest percolating in the mining community before the Great Strike of 1913.

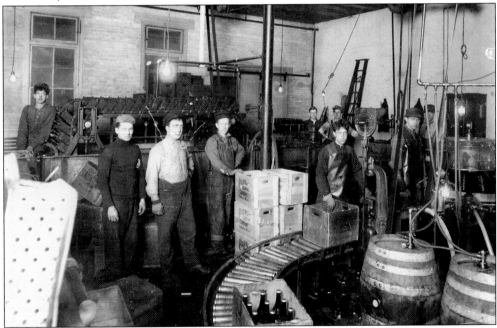

Beer was called "the fluid that lubricated the sinews of the mining district" by a pundit of the time. There were always more bars than churches. Hancock and the surrounding area supported many breweries during this period, including Bosch (the largest), Schneurmann, Park, Calumet, Portage, and Haas, to name a few. These workers are bottling Park beer, a popular Hancock brew.

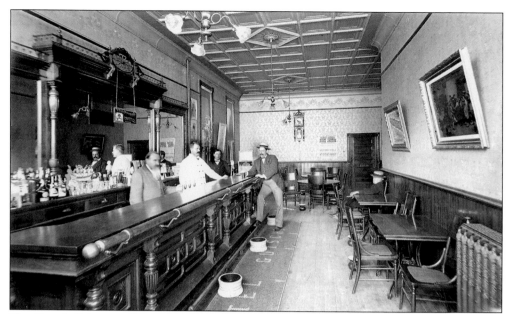

The Gutsch Saloon on Quincy Street was but one of the typical watering holes that offered the workers and miners of Hancock with the brew of their choice. While this photograph is not dated, the electric lights, the dress, and the wide-brim straw "skimmers" of the gentleman at the bar indicate the 1890s. Rather large crockery spittoons for chewing tobacco users sit by the foot rail.

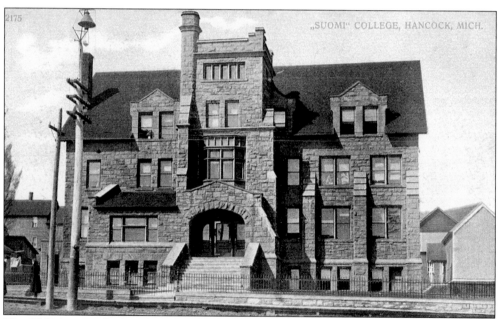

The Old Main was built at Suomi College in 1899. It was the first structure of the only college in the United States founded by Finns. Suomi College (now Finlandia University), founded in 1896, provided a two-year training program for Evangelical Lutheran ministers and practical nurses and preserved Finnish culture. The imposing building is constructed of beautiful, clear red Jacobsville sandstone. (Postcard by A. C. Bosselman and Company, New York.)

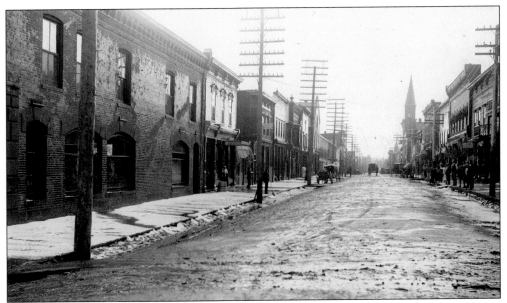

This 1880s view down Quincy Street, the main thoroughfare in Hancock, is one of brick structures and affluence, but streets still made of dirt. Paving would not come until the beginning of the 20th century. (Photograph by W. J. Uren.)

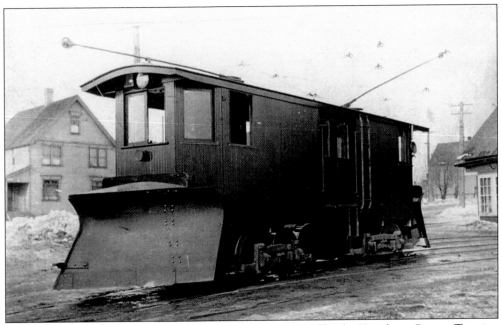

Houghton and Hancock, and much of the county, were served by the Houghton County Traction Company until the Great Depression hit in the 1930s. Pictured here is trolley line plow that made its home in the car barn in Hancock. The plow's size corresponds with the heavy snows falling in the region.

The No. 2 Hancock Mine, located farther up the ridge from the city, tapped a richer ore body than its predecessor. This mine organized and reopened in 1906 with better capital. A new shaft house and hoisting plant were constructed in an area northwest of Hancock called Klondike. The mine finally closed in 1920. Note the streetcar in this photograph.

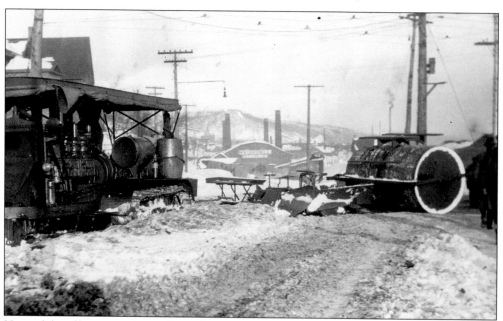

Heavy lake-effect snows have always been a challenge for the Houghton County road crews. In 1920s Hancock, this Holt Crawler tractor was used to pull a plow and a snow roller. The roller was used both before and after the advent of the automobile to "pank" down the snow. In the absence of large truck-mounted plows, the tractor allowed both horse-drawn sleighs and automobiles to travel the roads.

Six

FIRE AND THUNDER ON TORCH LAKE
LAKE LINDEN AND HUBBEL

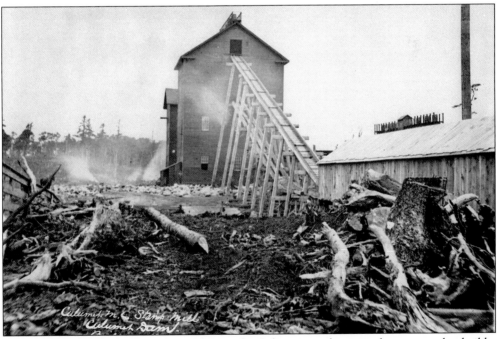

When Edwin J. Hulbert first began exploiting the Calumet conglomerate, he attempted to build a stamp mill near Calumet Lake (Pond), not far from the mines. The mill pictured here was a dismal failure, and when Alexander Agassiz took over in 1869, the plan was to send ore-bearing rock by tram and rail to the area of Lake Linden on the shore of Torch Lake. The mill failed because the pond lacked a sufficient water supply and, due to shallow depth, froze almost solid in the winter, further reducing water flow. The mill was based on roller-type rock crushers, which were not sufficient to deal with the hard rock and its high quantity of native copper. The rolls jammed almost as fast as they cleared. Needless to say, Hulbert was fired for lack of sensible planning or purchases. Agassiz tried for two more years to mill copper at this site using a Ball Stamp engine, a large steam-powered hammer, to break the copper free from the rock. But the water problem continued, and he moved the mill to Torch Lake. (Photograph by J. Childs, 1870.)

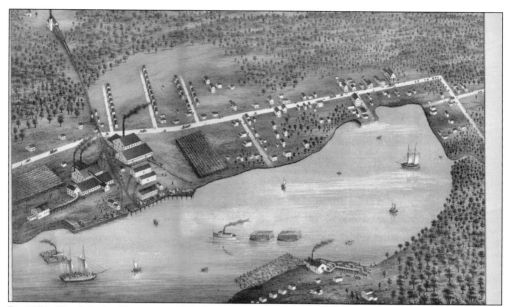

By 1872, Torch Lake (later named Lake Linden) had changed from a sleepy French Canadian logging town to a bustling mill town, with South Lake Linden as the site for the C&H smelter. In 1879 alone, between the middle of August and October, the smelter shipped more than six million pounds of copper. (Map by J. J. Stoner, Madison, Wisconsin.)

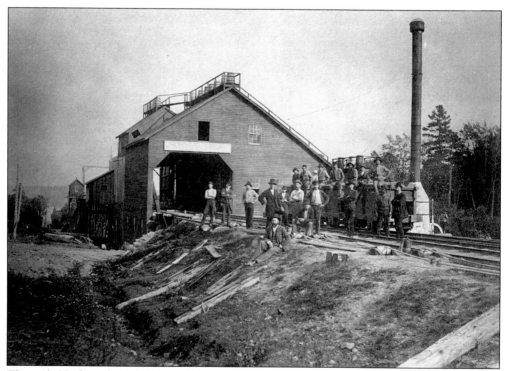

The early Hecla and Torch Lake Railroad ore cars met the incline to Lake Linden at this station, run by a tough Scotsman named McNaughton. He was the father of James McNaughton, who would rise to head the C&H during the 1913 strike (see chapter 10).

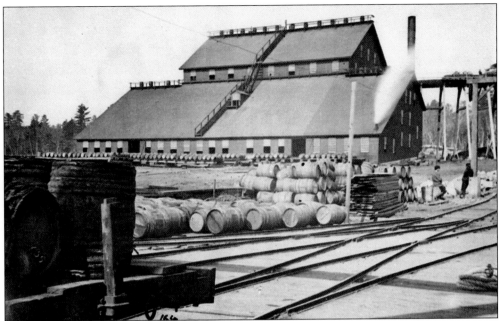

The cars were disconnected at the bottom of the incline and shuttled into one of the stamp mills. The Calumet Mill appears here on the left, while the Hecla is on the right. At this stage, around 1870, the Calumet Mill had only two low-pressure Ball-type steam stamp engines. By 1901, the Calumet and Hecla Mills would run 28 high-pressure Leavitt stamps seven days a week, 24 hours a day.

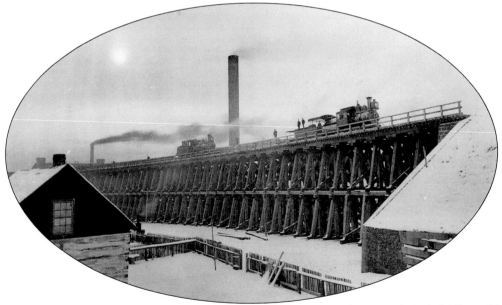

Once the Hecla and Torch Lake Railroad was completed, the Calumet and Hecla Mills could be served by steam locomotives. Rail delivery allowed much greater quantities of rock to be processed and smelted. This trestle, used to feed the mills, was eventually buried in a poor rock-and-earth embankment with only a tunnel over Calumet Street (Highway M26). (Acton Company, publisher.)

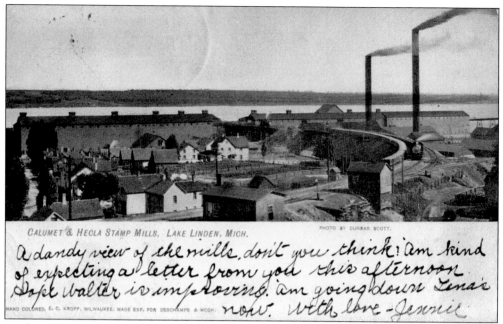

CALUMET & HECLA STAMP MILLS, LAKE LINDEN, MICH.

PHOTO BY DUNBAR SCOTT.

A dandy view of the mills, don't you think? am kind of expecting a letter from you this afternoon. Hope Walter is improving. am going down Tina's now. With love - Jennie

HAND COLORED, E. C. KROPF, MILWAUKEE. MADE EXP. FOR DESCHAMPS & MCGK.

As this 1889 panoramic postcard shows, the C&H mill and the village of Lake Linden grew apace. From 1872 to 1890, the population increased dramatically despite the terrible 1887 fire that burned most structures. The town continued to grow until it was the fourth largest in the county.

In this 1900 Isler photograph from the top of the Calumet mill stack, the village of Lake Linden spreads out along the shoreline in the direction of the Boniface-Eddy Sawmill and the busy town.

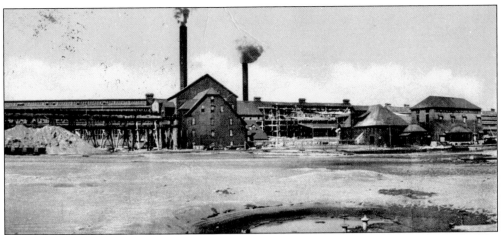

This 1899 panoramic reveals the huge Michigan pump and sandwheel buildings located in the center of the mill complex. The pump took millions of gallons of water from Torch Lake for the milling processes, while the 60-foot sandwheel lifted waste sand and water slurry to a level that allowed water pressure and gravity to wash waste sand into the lake.

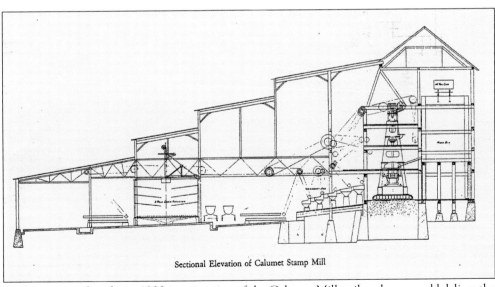

Sectional Elevation of Calumet Stamp Mill

As demonstrated in this c. 1900 interior view of the Calumet Mill, railroad cars would deliver the rock to rock bunkers, which fed the three-story-high Leavitt stamp engines. By 1901, twenty-eight of these machines would run day and night with a thunderous roar that could be heard throughout the community, called "the thunder on Torch Lake."

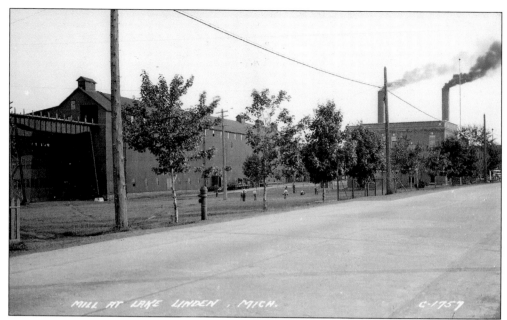

In 1910, the C&H constructed a new mill office building to replace an older frame structure. It housed offices, a clinic, the pay office, and a pharmacy for workers. Here, it stands in front of the greatly expanded Calumet Mill around 1915. The building now houses items from the collections of the Houghton County Historical Society, viewed by many visitors each year.

At the same time that Agassiz brought milling to the shores of Torch Lake, he also set up a smelter farther down the lake in an area called at various times Grover and South Lake Linden. Between the mill and smelter were the C&H coal docks and houses for both workers and management. This photograph shows the company-provided residences for management (Photograph by R. Acton.)

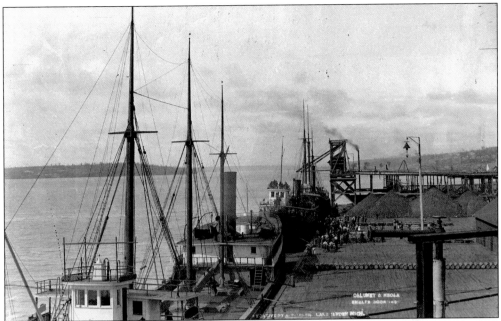

The coal docks in this 1880s Isler photograph were first served by early-design Hullett bucket loaders. A steel bucket with flanged wheels was lowered into the hold. It was filled by shovelers, then lifted up to the trestle. There, the bucket was railed onto tracks and pushed out to the coal pile location and dumped. Note the trestle ramp over each coal pile. (Photograph by A. F. Isler, Lake Linden.)

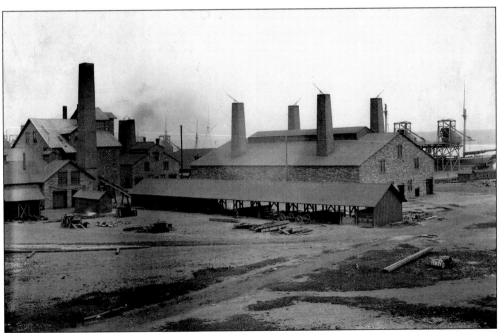

The refining furnace building, with its four square stacks, was constructed of variegated Jacobsville sandstone. Behind it are more of the coal and limestone unloading facilities. The shed in the foreground is a slag and conveyor shed. The large structure to the left is a cupola furnace and machine shop.

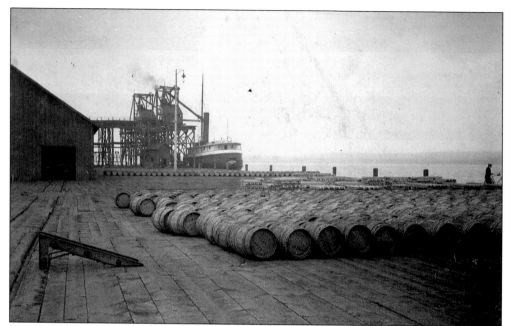

In the background, a lake carrier unloads either coal or limestone at the smelter dock. Lined up in the foreground are the "barrel work" or "barrel cooper." These barrels contained unsmelted ore sent broken from its surrounding rock to other smelters and refiners, where it would be used either in chemical production or in the production of alloys such as bronze.

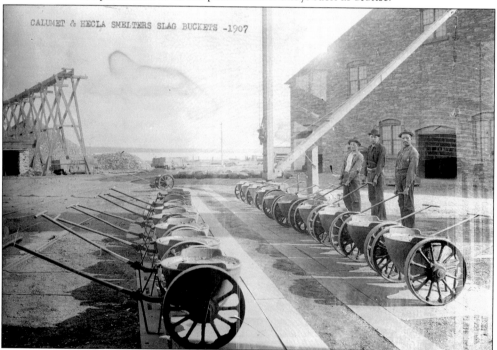

Slag, the byproduct of smelting, had to be removed from the top of the molten copper and then carted away for dumping by hand labor. In 1907, this was still the case. By 1915, however, the smelter had a 36-inch-gauge railroad to handle the process.

Locomotive No. 3, one of five Porter 36-inch-gauge locomotives in operation, moved ore concentrate, slag, and other items about the mill complex. This locomotive still runs today on the campus of the Houghton County Historical Society, where it is used to conduct tours of the former C&H mill site.

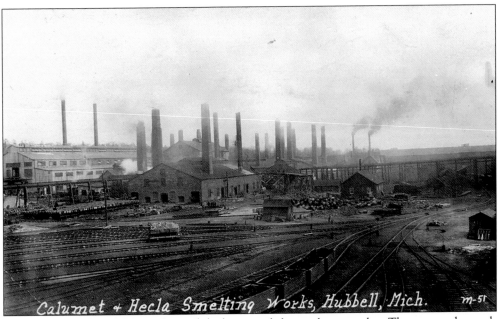

Calumet + Hecla Smelting Works, Hubbell, Mich. m-51

This c. 1915 view looks from the coal docks toward the smelter complex. The copper demands of the coming world war had sent the smelter into yet another growth spurt. Not only are there more furnaces of the old style, but a huge new reverberatory furnace is visible in a steel structure in the background. (Postcard by the Co-Mo Company of Minneapolis.)

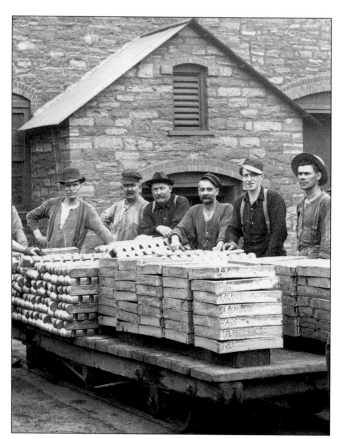

Copper in cakes was one of the heaviest forms used for shipment. It was tested and cast to the specifications of the customer. Here, workers take a break from loading to pose with a carload of cakes and ingots.

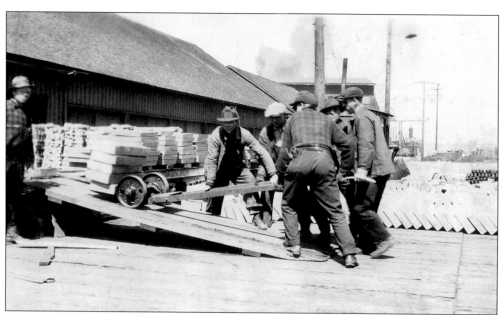

At the smelter dock, men unload cakes from a narrow-gauge flatcar using an unusual hand truck called a fanny. This may explain the origin of the expression, "Get your fanny moving."

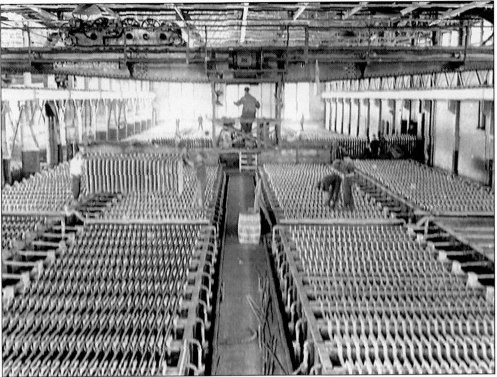

By 1900, the mines of the C&H were producing poorer quality ore, so the company responded with a plant near the smelter that would extract more copper through an electrolytic separation based on chemicals. This view shows the plant interior with the separation baths and plates. Note the overhead crane. (Stereoptical view by Keystone-Mast.)

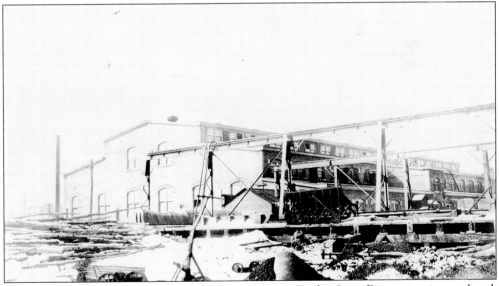

The electrolytic plant only produced for about 20 years. By the Great Depression, it was closed. The site was later used as an indoor tennis court until the 1970s, when it was purchased by Peninsular Copper Industries, producers of copper-based chemical products.

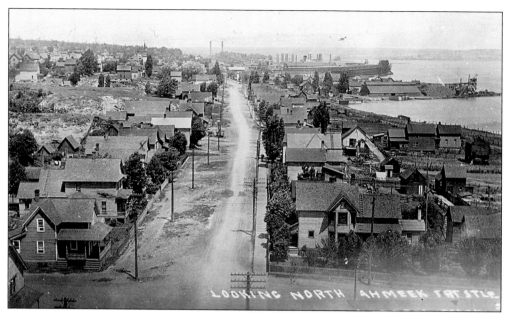

By the start of the 20th century, the smelter had increased the fortunes of South Lake Linden, which had become a village of 1,500. In 1903, the name of the village was changed to Hubbell to commemorate Congressman Jay Hubbell.

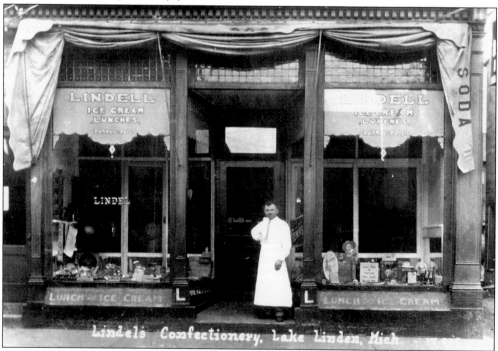

In 1902, two Greek immigrants named Pallis and Grammas opened two candy and lunch counter operations, one in Lake Linden and the other in Hubbell. The Lindell Chocolate Shoppe was moved from this location to the former Bosch store building around 1918. The name Lindell derives from the splicing of Lake Linden and Hubbell. The still-operating shop is listed in the National Register of Historic Places.

Snow is an ever-present battle in both Hubbell and Lake Linden, and the folks at the old Hubbell Hardware, owned by Joseph Wise, have their work cut out for them. This image dates to the winter of 1920.

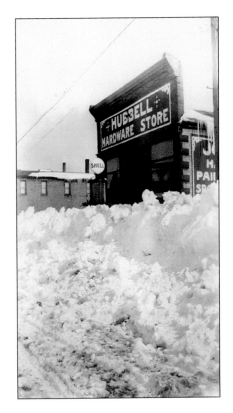

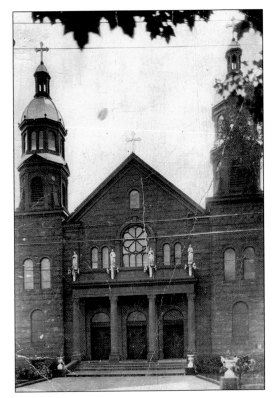

The French Canadian community of Lake Linden has supported its parish for over 150 years. This most recent of the St. Joseph parish churches was built in the early 20th century. The Eglise St. Joseph, built of pure red Jacobsville sandstone, is decorated with white stone carvings of the saints on the pediment over the main entrance.

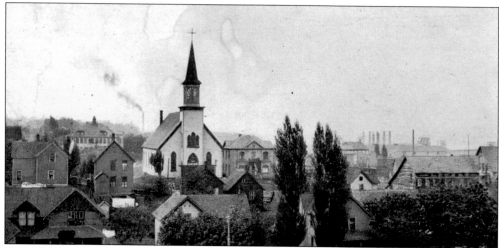

Hubbell's St. Cecilia Church appears in this 1898 postcard view as it was before the roof lowering of recent years. The church was built in 1893, and the first mass was read on November 1 of that year. Like St. Joseph's, the church also operated a school for many years.

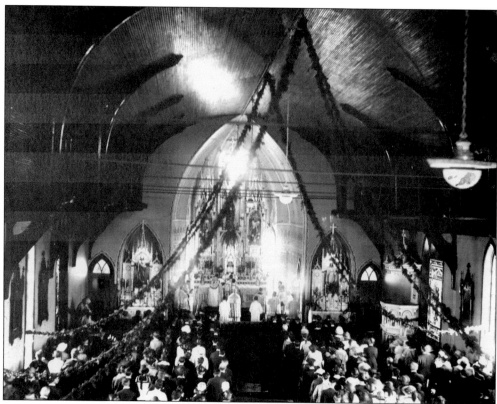

Before the recent roof modifications, St. Cecilia had a spectacular altar and side altars. The ceiling was made of hardwood, a popular choice when the structure was built. Here, it appears that Christmas mass is underway.

Like Hancock, Lake Linden has a city hall that rivals some of the religious structures in the county. The building was constructed of brick and Jacobsville sandstone in 1901. Listed on the National Register of Historic Places, the town hall is currently undergoing exterior restoration. (Postcard by A. C. Bosselman.)

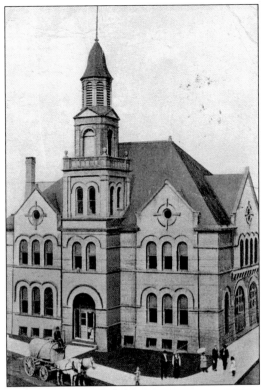

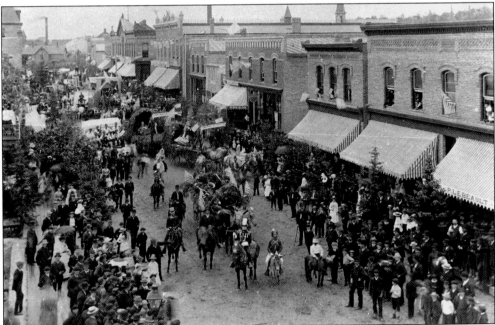

Since their beginnings, Lake Linden and Hubbell have both planned big Fourth of July celebrations. In 1888, Lake Linden had a lot more to celebrate than usual, as Calumet Street had recovered beautifully from the terrible fire of 1887, which had totally destroyed this section of town.

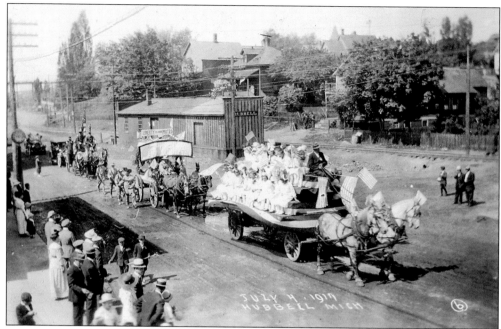

The Fourth of July parade in Hubbell passes by the old Mineral Range Railroad freight house and station in 1917. The Lake Linden depot was located to the right of the photograph, between Hubbell and Lake Linden.

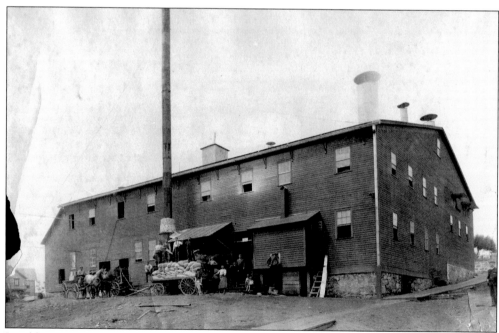

In addition to copper milling, the Lake Linden and Hubbell area was noted for one of the most popular beers in the area, produced by the Bosch Brewing Company. Started by Joseph Bosch in 1874 under the Torch Lake Brewery name, the distillery was burned in 1887 but later rebuilt. The warehouse is seen here after the fire.

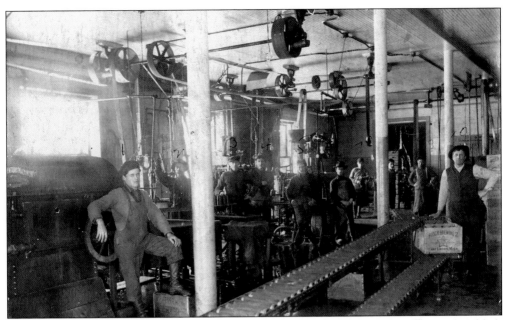

The interior of the Bosch bottling operations is pictured around 1890. Note the overhead belt drives for all of the machinery.

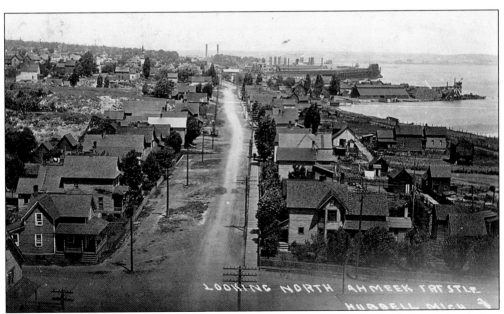

The main thoroughfare of Hubbell and Lake Linden remains Michigan Highway 26. In 1911, at the time of this postcard, it was still a dirt road. The photograph was taken from the top of the Tamarack Mill powerhouse smokestack.

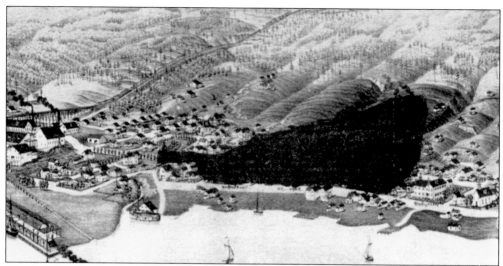

The fire of 1887, which destroyed Lake Linden's downtown business district, started in Neumann and Trelease's Store on First and Calumet Streets. The store was one of the few brick buildings in the commercial district, but that did not save it from devastation. This graphic shows the extent of the destruction. This is a retouched version of a map by J. J. Stoner.

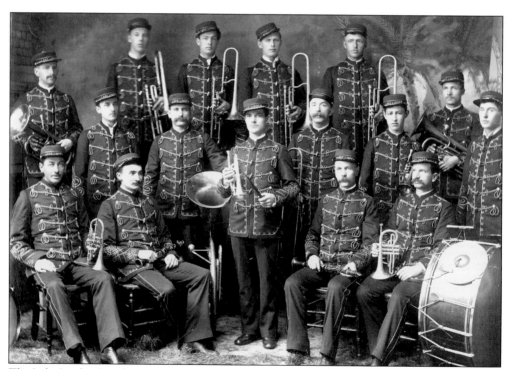

The Lake Linden Band, seen here in 1916, was a popular group at every Fourth of July celebration. The uniforms were dark-blue with wonderful gold piping. According to an early Polk's Directory, the band leader was Henry Smith, an engineer who lived in Hubbell. He is pictured in the center, holding a cornet and baton.

The Lake Linden Fire Department celebrated the 120th anniversary of its Fourth of July celebration and parade in 2005. The Hubbell Fire Department started a year later, in 1886. As evidenced by this handbill, sports competitions of all kinds were major features of the event. Fireworks and music were, and still are, favorites.

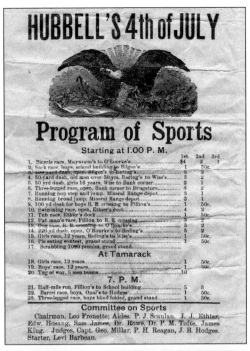

HUBBELL'S 4th of JULY

Program of Sports

Starting at 1.00 P. M.

		1st	2nd	3rd
1. Bicycle race, Mayworm's to O'Rourke's	$4	2	1	
2. Sack race, boys, school building to Bilgen's	1	50c.		
3. 100 yard dash, open, Bilgen's to Reding's	5	2		
4. 50-yard dash, old men over 50 yrs. Reding's to Wise's	3	2		
5. 50 yrd dash, girls 16 years, Wise to Bank corner	2	1		
6. Three-legged race, open, Bank corner to Drugstore	8	2		
7. Running hop step and jump. Mineral Range depot	8	1		
8. Running broad jump; Mineral Range depot	8	1		
9. 100 yd dash for boys R. R. crossing to Fillion's	1	50c.		
10. Swimming race, open, Ethier's dock	4	2		
11. Tub race, Ethier's dock	1	50c.		
12. Fat man's race, Fillion to R. R. crossing	3	2		
13. Dog race, R. R. crossing to O'Rourke's	3	2		
14. 220 yd dash, open, O'Rourke's to Reding's	5	2		
15. Girls race, 12 years, Reding's to Wise's	1	50c.		
16. Pie eating contest, grand stand	1	50c.		
17. Scrabbling 1000 pennies, grand stand				

At Tamarack

18. Girls race, 12 years	1	50c.
19. Boys' race, 12 years	1	50c.
20. Tug of war, 5 men teams	10	

7. P. M.

21. Half-mile run, Fillion's to School building	5	3
22. Barrel race, boys, Opal's to Hodges'	1	50c.
23. Three-legged race, boys blind folded, grand stand	1	50c.

Committee on Sports

Chairman, Leo Frenette; Aides. P. J. Scanlan, J. J. Ethier, Edw. Hosang, Sam James, Dr. Rowe, Dr. P. M. Tofte, James King. Judges, Capt. Geo. Millar, P. H. Reagan, J. B. Hodges. Starter, Levi Barbeau.

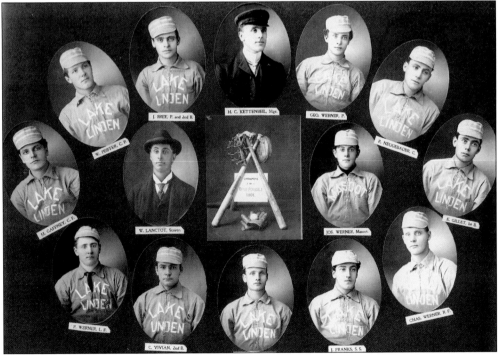

Organized sports like hockey, baseball, football, and even cricket were popular, and not just at the public-school level. Many community teams were formed, such as the Lake Linden Men's Baseball Team, which won the 1901 Upper Peninsula Championships. Manager H. C. Kettenbeil, who also worked for Bosch Brewing as a bookkeeper, owned a share in the Emporium Saloon (Kettenbeil and Son) at 209 Calumet Street.

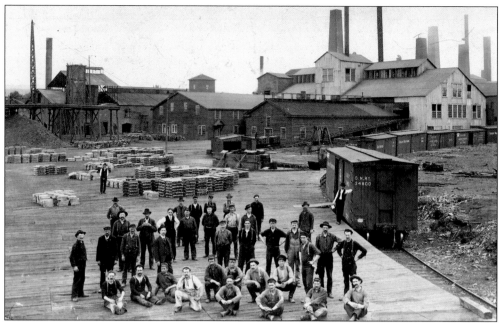

Piles of copper ingots await loading while the crew poses at the Lake Superior Smelting Company in Dollar Bay. The smelter provided contract smelting services for various mines in the area as well as its parent, the Tamarack-Osceola Mining Company, which had offices in Dollar Bay. Though owned in Boston, the mill was run locally by superintendent H. D. Conant. (Photograph by A. F. Isler, Lake Linden.)

The Hancock Chemical Company had its offices in Dollar Bay as well, not too far from the smelting works. Hancock Chemical, producer of blasting powder, succumbed to competition from the Dupont Nemours Senter Works, which moved into the area not long after a major explosion at this plant in November 1887. The explosion totally destroyed the packing house and killed a man and five boys.

Seven

FREDA, PAINESDALE, AND THE SOUTH RANGE

The mines of the Copper Range Company were the driving forces for the development of the communities of South Range, Baltic, Trimountain, Atlantic Mine, Painesdale, and Freda. This antique railroad plat map from the state survey of 1895 shows the locations of the towns, mines, connecting rail lines, and mills. This region mined two major lodes: the Atlantic Amygdaloid, discovered in 1864; and the Baltic Amygdaloid, discovered in 1882. The word "amygdaloid" is taken from the Greek *amygdos*, which translates to the English almond. It describes the almond shape of the tiny particles of pure copper embedded in the rock (ore). These types of ores brought great riches to the stockholders and owners of the companies that mined them. With companies using ever-improving stamp engine technology, yields as high as 95 percent pure copper were not unexpected after milling.

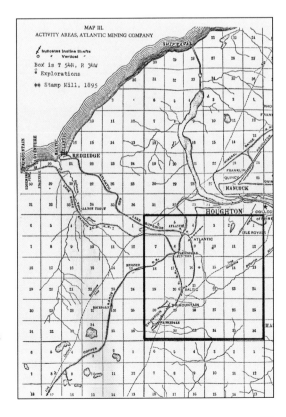

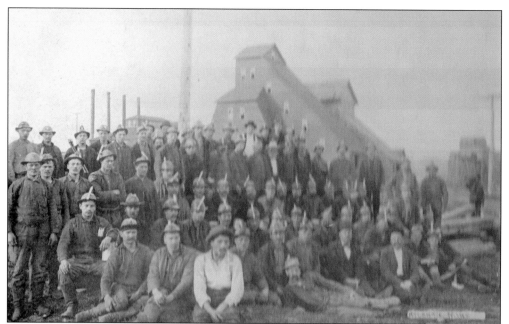

The Atlantic Mine was the oldest of the mines in the area south of the Portage Lake. The Atlantic began in 1872 as the consolidation of the South Pewabic Copper Company and the Adams Mine. Both of these mines had made some progress with the Quincy in extracting copper from an ore similar to the Amygdaloid Lode, but were improperly managed. Note the miners wearing candles on their caps; standard gear until the 1890s for underground work. (Photograph by O. F. Tyler, Calumet.)

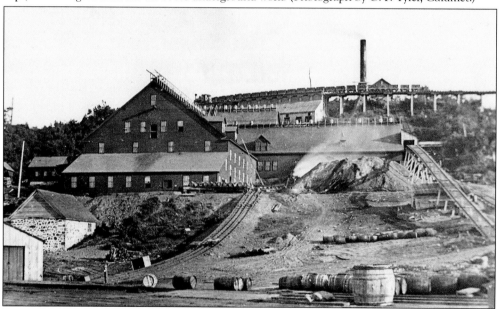

Because of the poorer grade of rock that predominated the Atlantic Mine's holdings, a well-run mill was required to get the most out of what was mined. The old mill at Cowles Creek, pictured here, was used initially, but in 1891 plans were made to build a new mill at Redridge, where the tailings could be dumped directly into Lake Superior. The Cowles Creek mill was located on the Portage Lake.

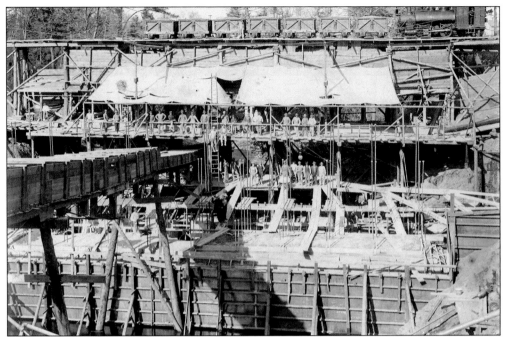

For the new mill, Atlantic and its partner, the Baltic Mine, needed to hold back the waters of the Salmon Trout River to use them for ore processing. The company built an innovative steel dam, with the mill directly in front of it. In this photograph, the locomotive pulls a string of ore hoppers over the mill's new rock bins.

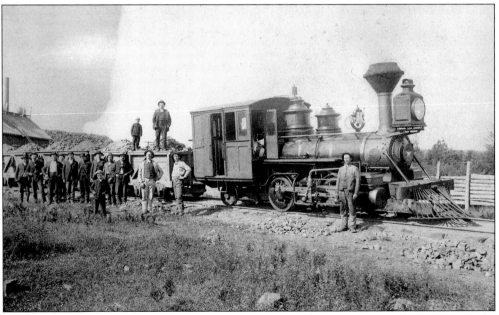

The locomotive *Joseph E. Gay* was purchased in 1891 for $9,100. It was used to transport the Atlantic ore to the mill at Cowles Creek, but starting in 1895, it traveled to the new mill at Redridge. Built by Brooks Locomotive Works, the locomotive was an 0-6-2 wheel arrangement. It is seen here with a string of jimmies fully loaded with ore for the mill.

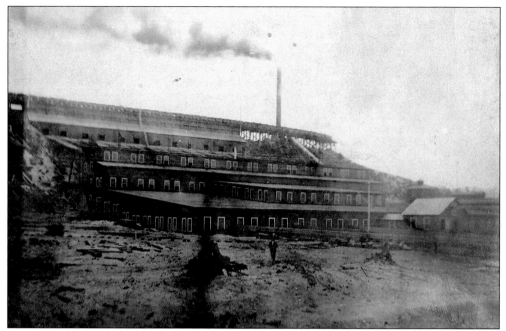

When completed, the new Atlantic Mill (left center) housed six low-pressure Ball stamp engines, 168 Collum jigs, and 28 Evans slime tables. The installation cost more than $300,000. The company built nine homes, a schoolhouse, a boiler house (lower right), a warehouse, and an electric lighting plant.

In 1909, the townspeople of Atlantic Mine and Redridge joined for a reunion commemorating the 1906 closure of the mine. The remains of the operation were sold to the Copper Range Consolidated Mining Company in 1911.

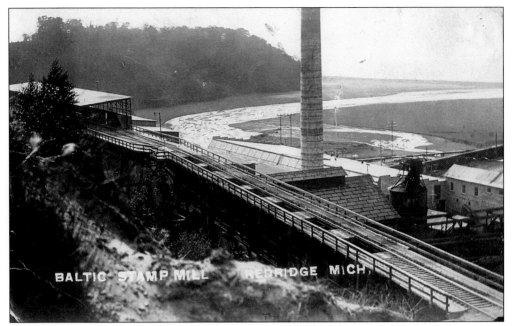

The Atlantic and Baltic Mines shared the expense of the Redridge steel dam, one of only three ever constructed worldwide. The Baltic built its mill just south of the Atlantic Mill. This view looks from the railroad trestle at the top of the mill toward Lake Superior. The ore unloading area is under the roof to the left. The powerhouse, with its tall stack, appears in the center.

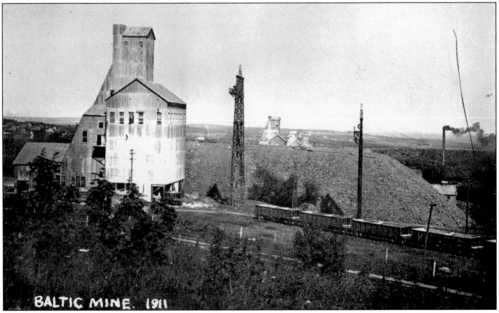

The Baltic Mine, located to the southeast of the Atlantic Mine, opened in 1897. Tapping the Baltic Amygdaloid Lode with a total of five shafts, it was soon incorporated into the Copper Range Consolidated Mining Company. The mine was profitable until its closure in 1932. Four of the five shaft and rock houses can be seen in this 1911 view. Copper Range Railroad ore hoppers are visible in the foreground.

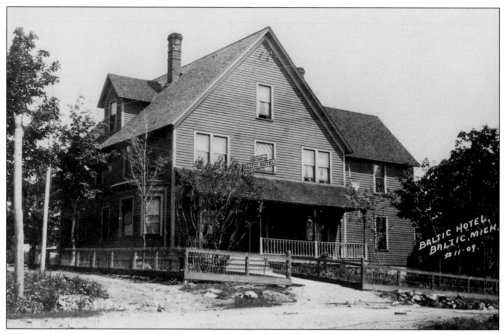

Baltic, Michigan, the town that grew up around the Baltic Mine, was built by the mining company at the same time the shaft opened. The town included a school, a couple of churches, about 30 dwellings of various sizes (depending on rank in the organization), and the Baltic Hotel, pictured here in 1909.

The mining captain and the agent were provided with nice homes such as these. The company store was located right next to these houses. The top of one of the shafts can be seen above the store building.

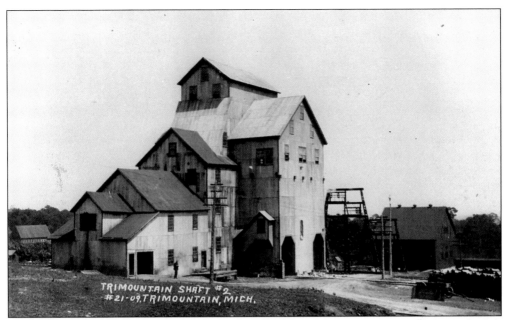

The Trimountain Mine, tapping the Baltic Amygdaloid Lode with four shafts, was located south and west of the Baltic, following the deposit. It was opened in the spring of 1900. A considerable amount of equipment for this mine was acquired from the Arcadian Mine north of Portage Lake when it suspended operations in 1903. The No. 2 shaft is pictured here in 1909. This mine closed in 1931.

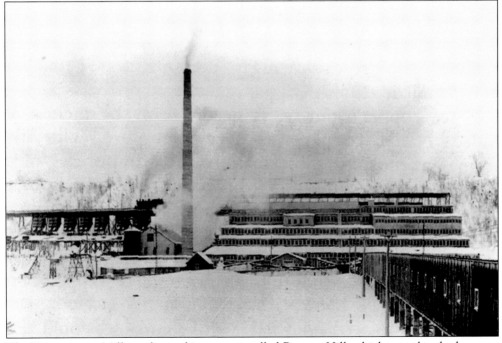

The Trimountain Mill was located in an area called Beacon Hill, which was also the home to many of the company management, hence the name. Unfortunately, the mill burned in 1916. The ore was then processed at the Champion Mill in Freda.

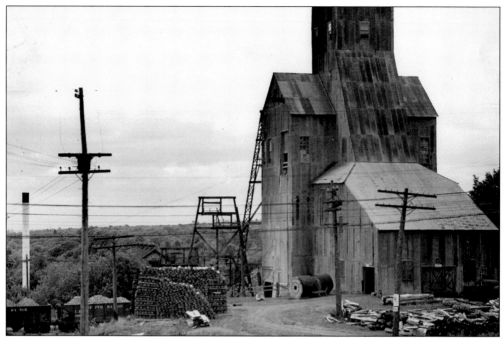

Opened in 1899, the Champion Mine, the most southerly of the mines tapping the Baltic Amygdaloid Lode, was also the longest producer of the group, closing in 1967. In the Champion operation were four shafts, lettered A through D. The D shaft still stands and is controlled by a non-profit group of local residents called Save Our Shaft seeking to preserve it.

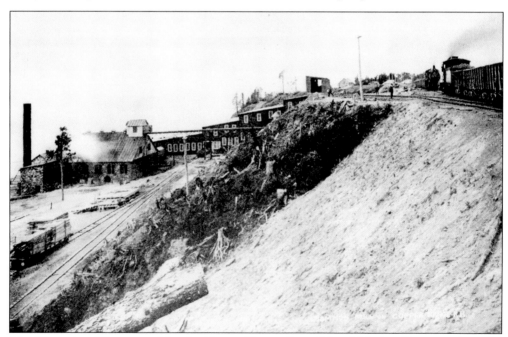

The Champion Mine, owned by the Copper Range Consolidated Mining Company from the beginning, built a stamp mill on Lake Superior at a place called Freda. Freda was named after the sister of William A. Paine, president of the Copper Range Company.

92

In 1898, William A. Paine, a senior partner in the firm of Paine, Webber, and Company, founded the Copper Range Company. This firm, supported with an ample supply of investor money, formed around the Champion Copper Company and the Copper Range Railroad beginning in 1899.

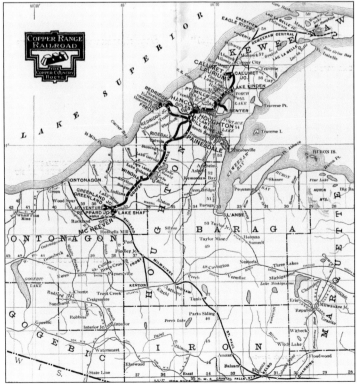

The Copper Range Railroad grew from an idea of Charles Wright, manager of the Hancock and Mineral Range Railroad. He wanted to build a railroad that would develop the Keweenaw and the South Range in areas inaccessible for mining without a railroad. He gained the ear of William Paine, and the Copper Range Company was formed in 1899.

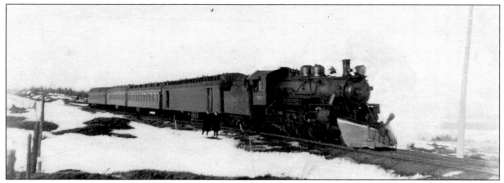

The Copper Country Route, as the Copper Range called itself, made joint trackage agreements with the Chicago, Milwaukee, and St. Paul Railroad (Milwaukee Road) in 1910. A 36-hour trip to Chicago in the electric-lighted Copper Country Express became a reality.

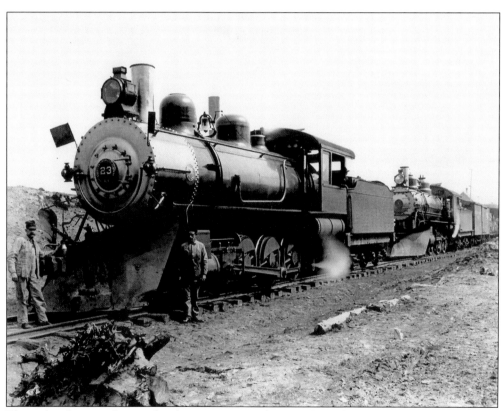

The railroad invested in quality locomotives, in this case No. 23, a 2-8-0 Consolidation from ALCO-Dickson, and No. 52, a Baldwin 4-6-0 Ten Wheeler for pulling passenger service. No. 52, shown here, is attached to a "mixed train," with a boxcar and flatcar for freight and at least one coach or combine for local passenger service. The Consolidation may be put into helper service.

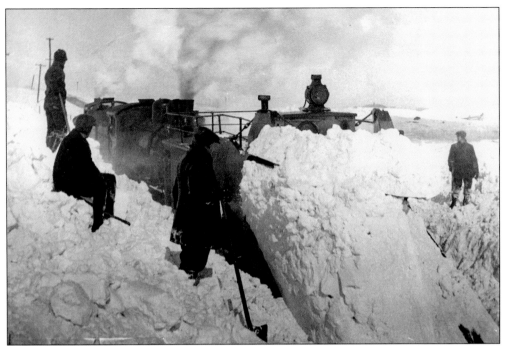

Sometimes Lake Superior could dish up snows that would stop even a fast and efficient outfit like the new Copper Range Railroad. A group of Copper Range "gandy dancers" has traded hammers for shovels to help this plow train through the drifts on the Lake Linden hole track in 1923. The plow is an early-model Russell, very popular with Keweenaw railroads.

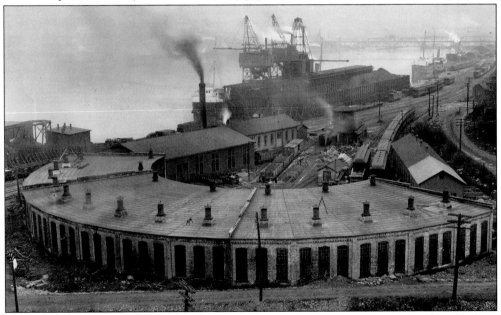

The Copper Range under Paine built modern and well. The engine facilities, located on the shore of the Portage Lake in southwest Houghton, were efficient. The 13-stall roundhouse, the car shops, the machine shops, and the Hullett unloader-equipped coal dock were all constructed to the latest 1900 standards. The freight yard and Copper Range docks appear in the right distance.

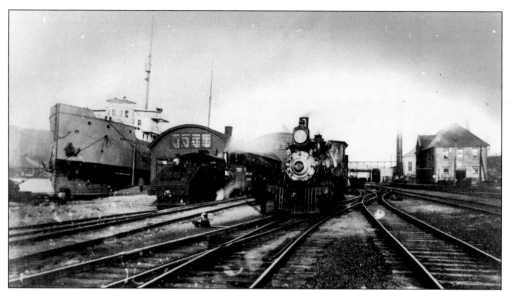

Both New York Central and its arch competitor, Pennsylvania Railroad (see chapter 9), had significant fleets of ships on the Great Lakes. Here, the Copper Range Company dock plays host to the New York Central steamship Milwaukee, which unloads and then acquires copper ingots and passengers for a trip down the lakes. Copper Range No. 1, a Baldwin 0-6-0 switch engine, shunts a boxcar to the dock warehouse.

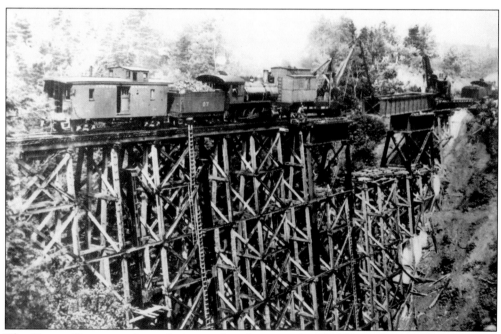

The Copper Range continuously invested and improved its holdings. Copper Range No. 27, an ALCO 2-8-0, and another unidentified locomotive perform maintenance-of-way work on a temporary wood trestle built over one of the Firesteel River's two branches. Copper Range is replacing the wood trestle with a steel-plate girder viaduct-style bridge.

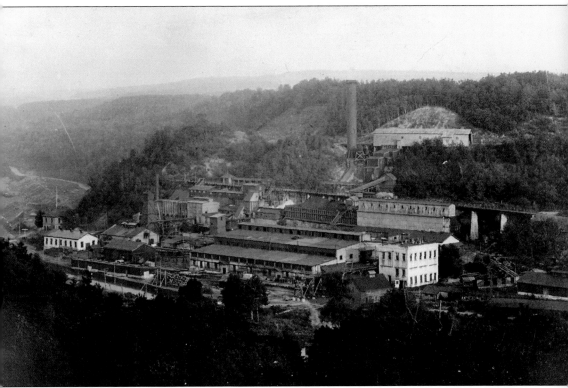

The Michigan Smelting Works was another subsidiary of the Copper Range. Designed by Frank Klepetko, the smelter was built in 1903. Several large surface plants stretched out along the shoreline of Portage Lake west of Houghton. The Copper Range provided most of the copper concentrates for its operation, but it also took in work from other mines. The smelter closed in 1952.

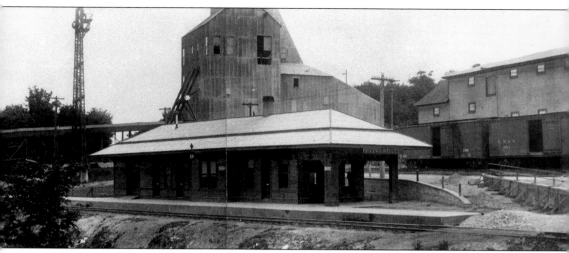

The Copper Range Company ceased after its merger with another firm in late 1976. By the mid-1960s, all serious mining in this region had ended, and the Copper Range was the last company actively mining copper. The Champion Mine in Painesdale, pictured here in a composite photograph from the 1920s, and the White Pine Mine in Ontonagon County were the firm's last viable properties. The White Pine closed under different ownership in 1995.

Eight

TIMBER TO THE FAR HORIZON

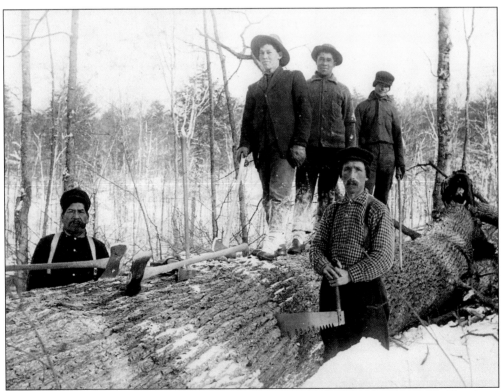

Years before the Quincy, Calumet, and Hecla Mines became economic factors in Houghton County, timber resources were under the axe of hardy (in most cases, French Canadian) loggers. They worked for camps supplying timber for the county, lumber for miners' housing and other construction, and fuel for the early steam-powered hoists at mass copper mines.

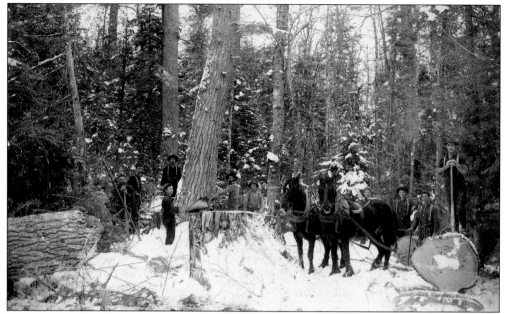

Using nothing more than muscle, broad axe, and crosscut saw, loggers worked in teams to fell the giant virgin white pine, hemlock, cedar, maple, and other hardwoods. A crew would normally work in teams of four to six cutters, with a driver and a helper for the horses. In spite of the extreme snow and cold, winter was the time to "skid" the logs from the forest. The work was so vigorous that few loggers wore their coats on the job.

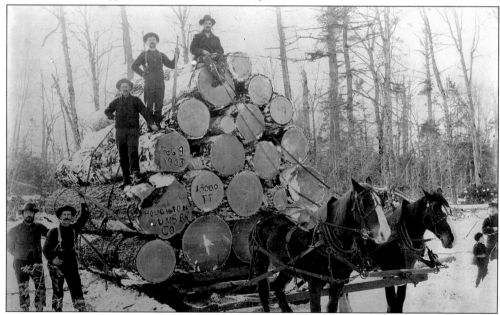

Once the logs were skidded out to a yard, they were loaded up onto large sleds for removal, either to a river or, later, to a waiting train, where they were transported to the mill. These sleds were encouraged to slide easily down the skid roads by the practice of icing with water. The snow was first packed with shovels or horse-drawn snow rollers, then a wagon with water and a sprinkler wet the road.

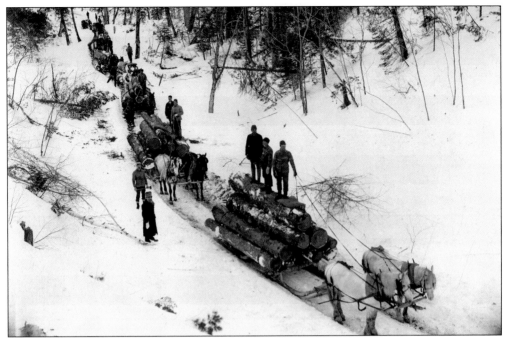

Quite often, a train of teams would head to the log pond at the mill. The properly iced skid road made it easy for the drivers to move as many as three loads in a day. Here, large white pine and hemlock are transported through the woods south of Houghton, now occupied by the campus of Michigan Technological University.

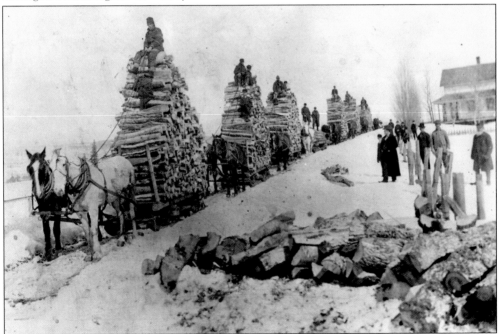

Sometimes the wood cut for firewood was harvested from stands of maple, birch (both white and yellow), and other hardwoods. It would be stacked very high, as the smaller logs could be stacked across the sleds. This photograph was taken on March 14, 1896, in the Traprock Valley.

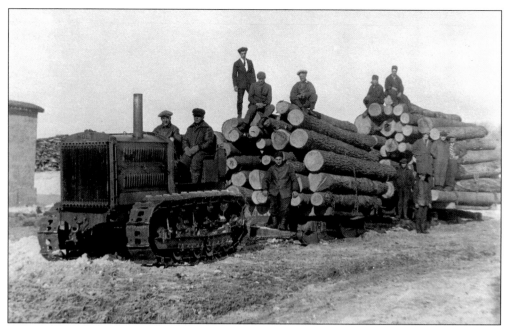

In spite of mechanization, skidding did not change much until the mid-1980s. In this 1920 image, a Sterns and Culver mill tractor tugs a couple of sleds full of what is likely native white pine. Hemlock was harvested because of its superior compression-load bearing ability for mine and bridge timbers. White pine made for superior construction and trim lumber, building rapidly growing American communities.

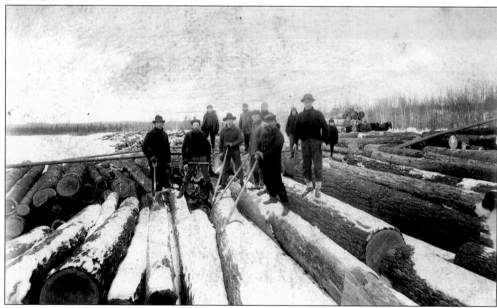

In the early years, once the timber was brought from a yard to the landing, it was typically floated on rivers and lakes to the mill. Rivers such as the Otter, the Sturgeon, the Tobacco, and the Traprock, and lakes like the Portage and Torch were used for transport. Here, a team drops off logs at Gauthier's Landing, offloading onto the winter ice preparatory to spring break-up and a float trip to the mill.

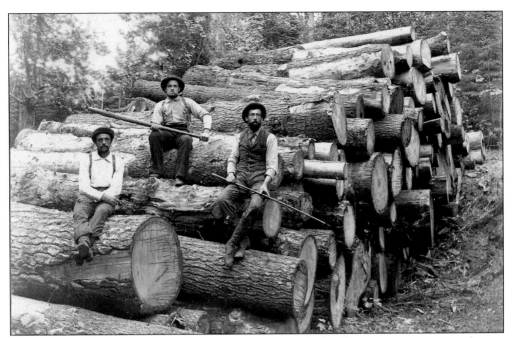

Since many different logging companies used the same body of water to transport cut logs, it could have been difficult to sort out the logs. This problem was solved at the yard or landing where a crew such as this recorded and marked the logs for the mill. Here, a crew prepares to stamp the end of each log with the company's mark.

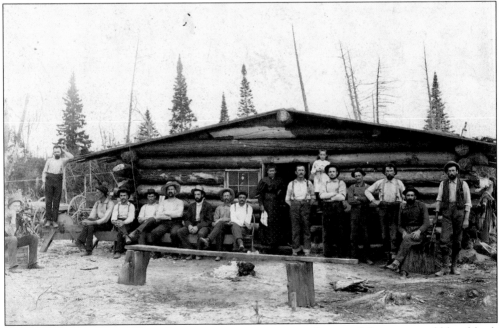

At the end of the day, the woods crews, cutters, cruisers, markers, and draymen would head back to the woods camp for the evening. The structures pictured here were traditional from the very earliest days of lumbering in North America. The only nod to civilization was the use of store-bought windows, brought in when the camp was set up.

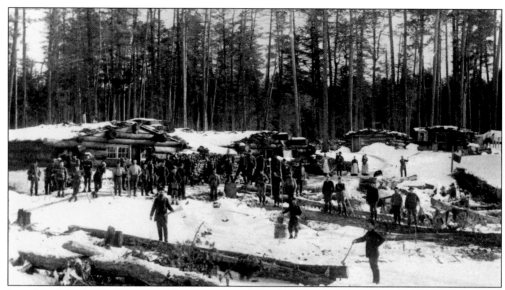

In spite of the male-dominated logging camp folktales, women often joined their husbands for the winter and helped with cooking. This photograph shows a typical crew and its housing, which included a bachelors' *camboose*, or camp, holding as many as 60 workers. Heat at night was provided by an open campfire in the middle of the dirt floor. Married camps were often divided into apartments, the walls consisting of heavy blankets, canvas, or rough-sawn wood to provide some privacy. More affluent woods workers or management would sometimes rate an individual cabin, as seen in the center background.

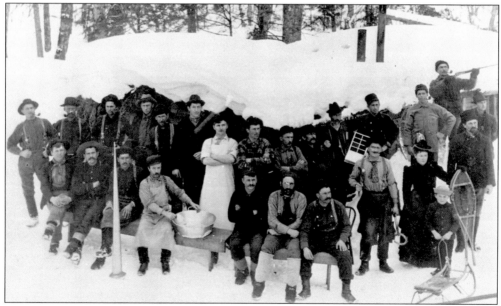

This image of a Keweenaw County crew reflects the typical makeup of a camp. Seen in this photograph are the caller, who blew the large keyless trumpet to call the shifts or fire alarms; the head cook and his assistant; the carpenter and the blacksmith, each holding the symbols of their trades; and the hunter, who brought in wild game and venison to keep the crew happy and off the salt-pork.

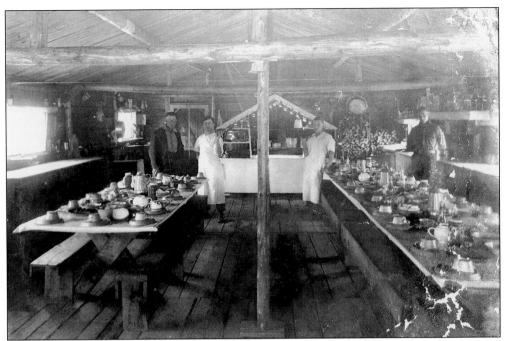

As the century turned and the logging camps had to compete with the mines for workers, the logging camps became more commodious. The cook staff at Camp 81 of this unidentified logging outfit have a professional layout. (Photograph by Ferguson, 1903.)

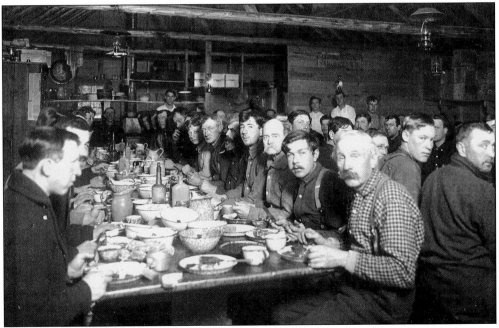

"Pass the 'taters and gravy." Men worked hard in the woods during the day and ate like kings in the camp at night. It is surprising that the crew of Diamano Company Camp 3 wanted to stop long enough to pose for the photographer! Usually, there was plenty of hot coffee to go around and with it plenty of eventful stories from the day in the woods. (Photograph by Ferguson, 1903.)

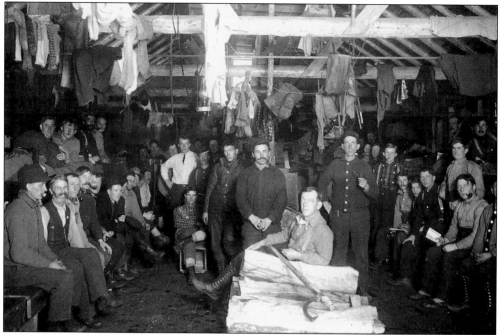

After a hearty meal, the loggers would retire to their camboose in order to stoke the fire, dry out wet clothing, and swap outrageous tales until retiring. Note the peavey, used to roll large logs on the stack of cordwood for the fire in the foreground.

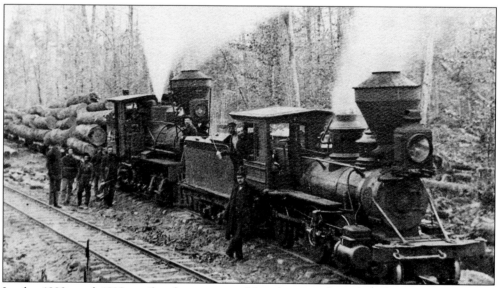

In the 1880s and 1890s, railroad transport of logs became the rule. The trainloads of logs represented both labor-saving and lifesaving measures for the loggers and mill operators. River and lake workers had very danger-filled lives; getting the logs to the mill by water kept the men at the mercy of river flow and wind. Even with steam tugs, lake transport was less efficient. In this photograph, locomotives of the Eddy Lumber Company take carloads of logs to the mill. The front locomotive is a conventional Baldwin 4-4-0, and behind is a Shay patent Class A geared.

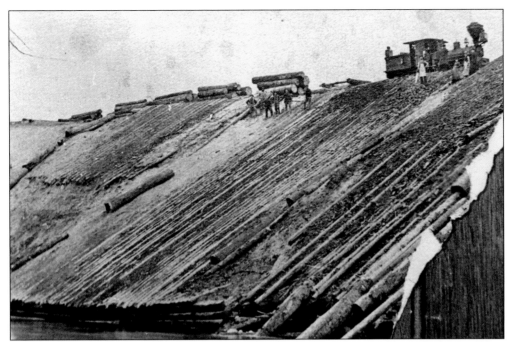

Here, the same Shay locomotive pulls its train by a gravity landing, where the logs drop down an inclined ramp into the mill pond. Just out of sight at the top of the ramp, a device called a jillpoke is used to push the logs off the cars and onto the ramp.

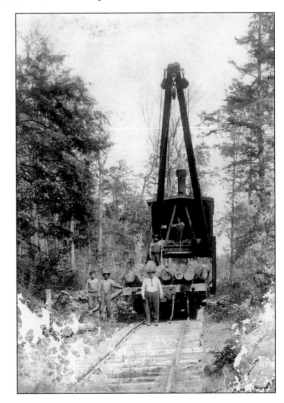

The loading of logs onto flatcars was also simplified by the introduction of steam log loaders and skidders, such as the one pictured. These devices were built by a variety of firms like Barnhardt and Company. They were also built from scratch by the larger logging companies.

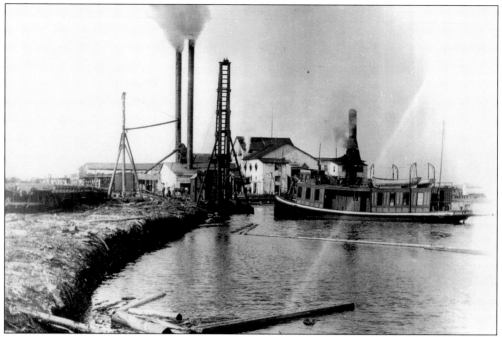

Large mills such as the Eddy in Lake Linden and the Worcester in Chassell (pictured) produced millions upon millions of board feet of lumber, mine timbers, and other wood products in Houghton County. (Richard Rupley Collection.)

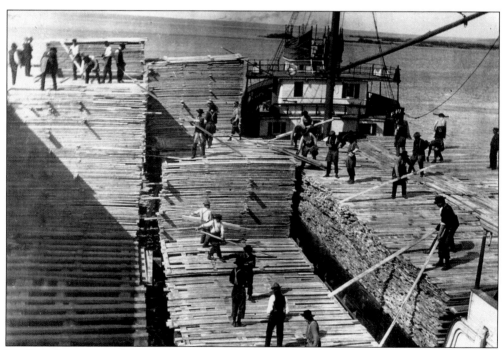

Lumber of various grades is loaded onto a small lake freighter, often called a lumber hooker in the white pine days. These small ships hauled to ports all over the Great Lakes, with Chicago being one of the most important. (Richard Rupley Collection.)

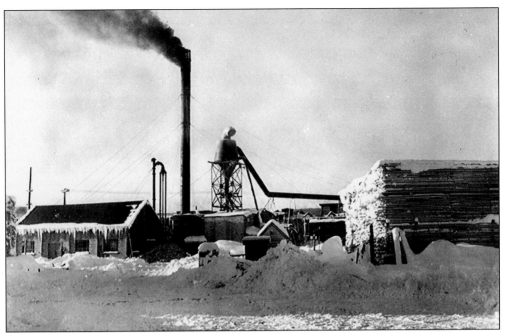

The abundant hardwood of the area also created a strong opportunity for the Hoerner Flooring Company of Dollar Bay. Founded in the late 1800s, the company is the world's foremost producer of basketball floors for the NBA and NCAA. This centennial business has retooled itself into the 21st century and is still prospering.

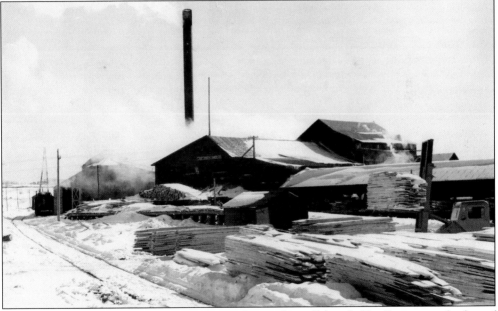

Samuel Eddy, who grew up in Lake Linden, took over the mill founded by Gregorie at the foot of Torch Lake and increased the business fourfold. The mill accepted logs from all over the Torch and Portage Lake basins. They were delivered by train and water, using the Sawmill Creek and Traprock River, as well as the waters of Torch Lake. The Bagley Railroad, which served the mill, also served the Craig, White City, and Jacobsville area.

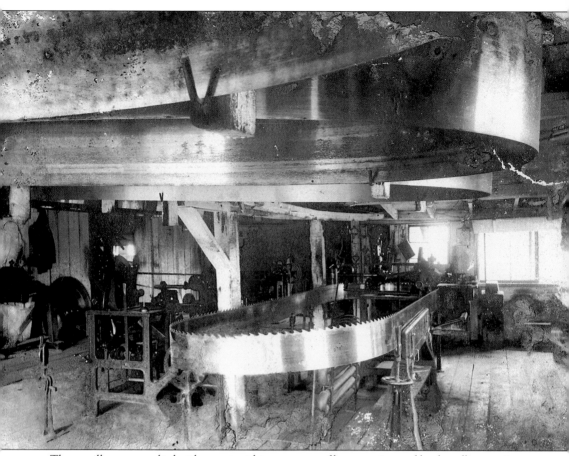

These mills were supplied with an astonishing amount of large cutting and log-handling equipment. The huge band saw blade shown here reflects the sheer size of the saws required to reduce virgin timber to usable board feet of lumber. At this point, the blade is in the shop for sharpening.

Nine

WHITE SQUALLS AND WHALEBACKS
SUPERIOR SHIPS

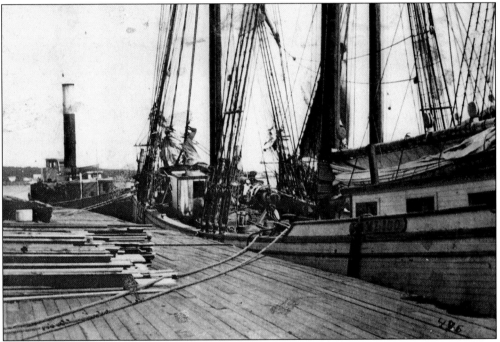

From the very beginning of the exploration of the Upper Great Lakes, Lake Superior has been the most feared because of its power, bone-chilling waters, and tremendous storms. Houghton County's location at the base of the Keweenaw Bay made it a safe harbor for the shipping that needed to ride out the fury of the lake. In the early years, all materials used by the mines and mills of the Copper Country arrived by sail or early steamship, as in this dock scene from Houghton in the 1880s. The primary trip up the lakes usually took two to three days from Detroit to the Straits of Mackinaw if the weather was good. Before 1850, at the straits, one had to take small bateaux or freight canoes, or the sloop *Fur Trader*, to the Keweenaw. After the government funded construction of the St Mary's Canal, a steamer could make the peninsula in two days. Once there, it required offloading to canoes, small sailing ships, and bateaux to go the next miles to Houghton. In 1860, the canal was enlarged and deepened.

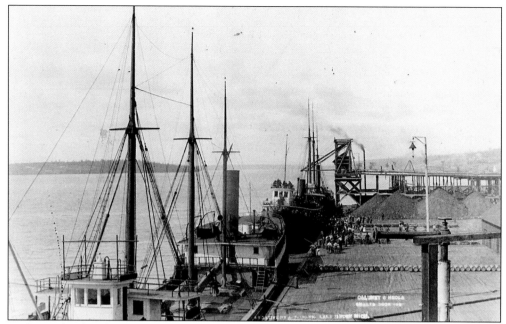

In this early Isler photograph, steamships and schooners share berths at the C&H coal dock in Hubbell (South Lake Linden) in 1880. The early steamers and barges still maintained sailing rigs, masts, and booms to be used for the loading of cargo and in the event of a troubled engine, which was quite common.

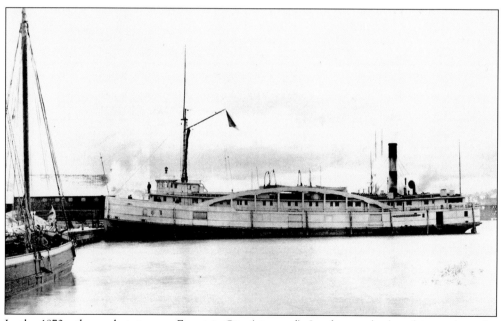

In the 1870s, the packet steamer *Fountain City* (pictured), *Ivanhoe*, and other ships such as the *India* plied the waters of Lake Superior and Keweenaw Bay delivering goods, because the roads were mainly two-ruts and converted Native American trails. The *Ivanhoe's* 1872 manifests show pianos, grandfather clocks, mine machinery, bolts of dressmaker fabric, rugs, and all manner of goods aboard. (Photograph by R. Acton.)

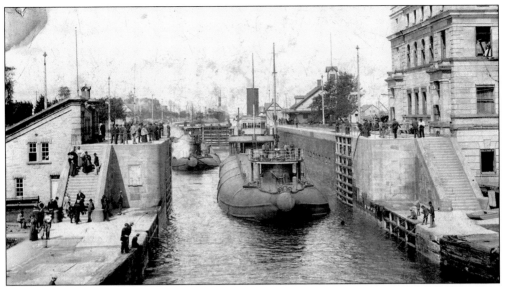

Developed by marine architects around the time of the Civil War, the whaleback steamship design for lake freighters and even excursion steamers became popular. It supposedly provided a more seaworthy and stronger iron hull design for the special needs of bulk carriers on the lakes. The whaleback steamships also sported 100 percent iron hulls with riveted plates. The cargo compartment was divided into a series of holds to carry grain, iron ore, coal, and other bulk materials.

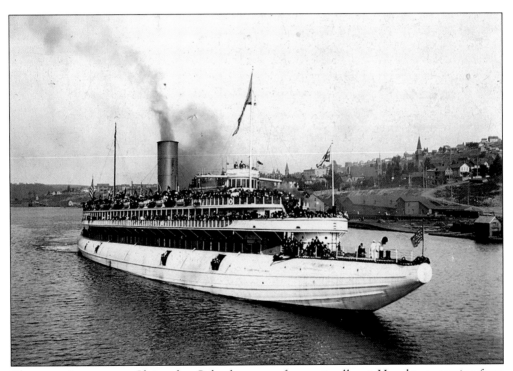

The excursion steamer *Christopher Columbus* was a frequent caller at Houghton, coming from Duluth and other south shore ports. It is bound for Duluth in this 1889 photograph, with Houghton in the background.

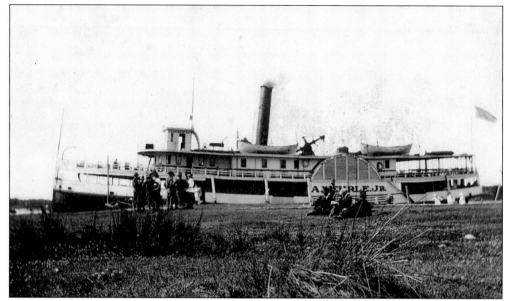

The small sidewheeler *A. Weherle Jr.* sported a walking beam steam engine. Built just after the Civil War, it plied Keweenaw Bay for many years between L'Anse and Houghton/Hancock. In later years, it was used in excursion service on the run to White City and as a ferry to the South Entry.

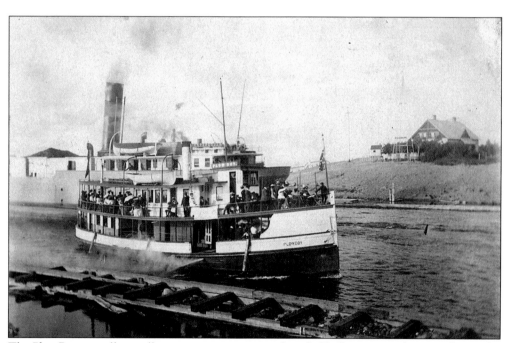

The *Plow Boy*, a small propeller steamer, passes an unidentified bulk carrier at the seawall near the South Entry Coast Guard Light Station. The *Plow Boy* and its sister ship, the *Sailor Boy*, would take passengers from Houghton, Hancock, and Lake Linden to the pavilion and amusement area at White City near Jacobsville, Craig, and across the canal from South Entry.

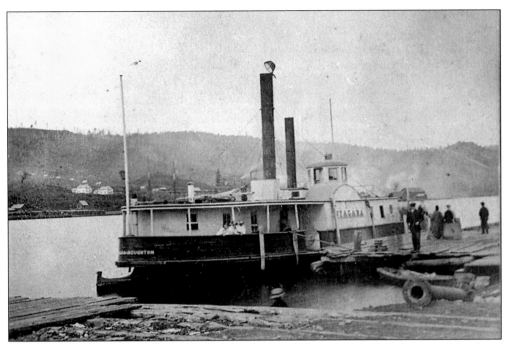

The old paddlewheel ferry *Niagara* crossed the Portage Lake waterway daily between Houghton and Hancock. Eventually, its services were no longer needed, as the bridge across the Portage carried more and more traffic. By the end of 1890s, it was out of service.

At the end of the 19th century, the more conventional bulk carrier design began to replace the rather unsuccessful whaleback and sailing barge carriers. Incorporating coal-fired high-pressure boilers and steel-plate hulls, these ships began to call on the coal docks of the Copper Country with loads of iron ore and grain from such ports as Duluth and Two Harbors, Minnesota, and Superior and Ashland, Wisconsin.

Even the Calumet and Hecla Mining Company owned its own steamship, the *Black Rock*, which carried milled ore to smelter operations at Black Rock Harbor in Buffalo, New York. (Photograph by A. F. Isler, Lake Linden.)

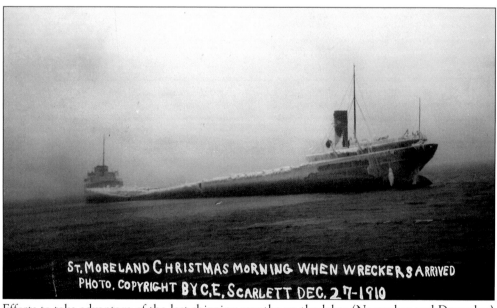

Efforts to take advantage of the last shipping months on the lakes (November and December) have put more boats on the bottom than any other single factor. The *William C. Moreland*, however, went aground on Sawtooth Reef on October 8, 1910, due to pilot error. There were so many storms on Superior that year, that the stern of the ship was not recovered until the next August. (Postcard by C. E. Scarlett.)

The Sand Point Lighthouse was built in 1878 at a cost of $10,000. It warned ships off of the Sawtooth Reef on the western shore of the Keweenaw near Eagle River. In spite of its best efforts, ships like the *Moreland* still found the reef. Sand Point is one of 17 lighthouses on the Keweenaw Peninsula.

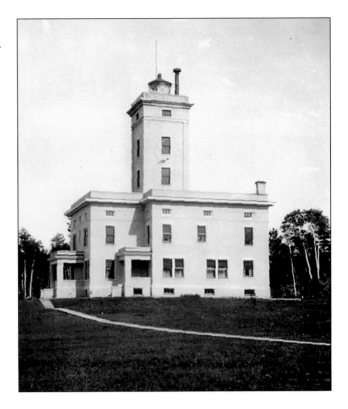

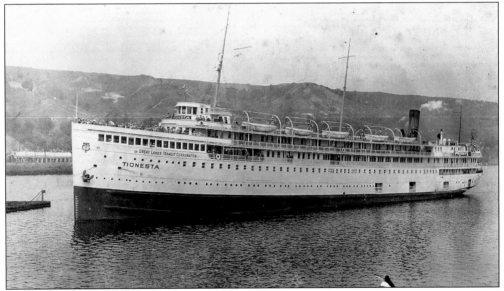

The 340-foot steamer *Tionesta* and its sister ships, the *Octorora* and *Juniata*, were operated by the Great Lakes Transit Company, a division of the Pennsylvania Railroad. They made frequent trips from Buffalo to Duluth. On their list of ports was Houghton, which they visited three days a week. Except for the *Juniata*, the vessels were commandeered by the U.S. Navy during World War II and then scrapped. The restored *Juniata* is now known as the *Milwaukee Clipper* and is a living museum in Muskegon, Michigan.

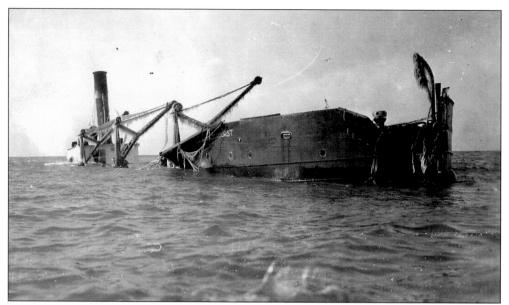

Shown here is all that remains of the 230-foot Canadian steamer *Maplehurst*. It went down in a storm off the Portage Canal on the night of December 1, 1922. While some were rescued, the captain and a number of crewmen lost their lives.

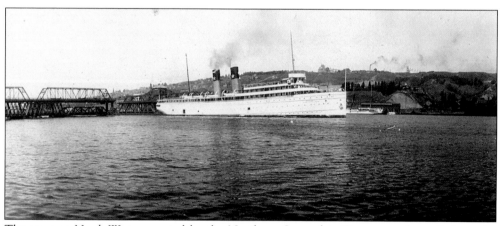

The steamer *North West*, operated by the Northern Steamship Company, also called on the Houghton area in the early 1900s. Here, it passes the Portage swing bridge, bound for Duluth. The bridge carried both vehicular and rail traffic across the canal.

Ten

STRIKE! THE BEGINNING OF THE END

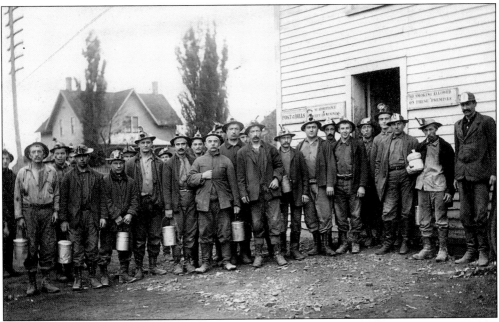

From the middle of the 1890s, the mining companies' growth in the Copper Country required a push farther afield to find immigrant miners, trammers, and muckers to work in the mines and surface plants. Recruiters were sent to the Balkans, Finland, Italy, and many other places to find labor. Along with the labor, in particular from Finland, came increasingly socialist ideologies. During this period, Finland was part of the cauldron of unrest that was Czarist Russia, in turmoil with the new ideas of Karl Marx. Even though accidents in the Keweenaw copper mines were lower than the national average, the issue of the eight-hour work day, and workman's compensation were burning issues. In spite of the inequities of late-19th-century society, the old system worked for many. Not until around 1900 did the mining companies begin to realize that the cost of extraction was getting higher and the mines were becoming costlier and deeper. The companies turned to new technology to help reduce labor costs and improve productivity.

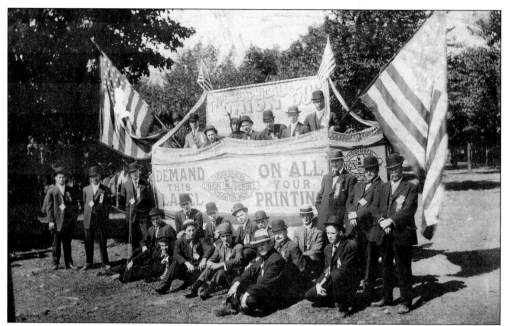

In the first decade of the 20th century, America and the Copper Country experienced the growth of the labor movement and the shedding of paternalistic management that had prevailed in the 19th century. In Houghton County, the mines began to see active organization under the aegis of a variety of unions, most prominently the Western Federation of Miners. As this image from Hancock shows, the labor movement covered many other industries as well.

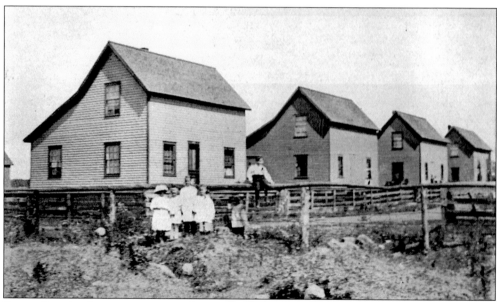

Paternalism in the copper mining district took the form of companies providing all of life's necessities for their employees. One- and two-family company houses dotted the landscape in places such as Swedetown, Coburntown, Bumbletown, and others. While simple, the homes provided warm accommodations for workers and their families. Single men were provided with boardinghouses. A company neighborhood at Osceola Mine is pictured here in 1913.

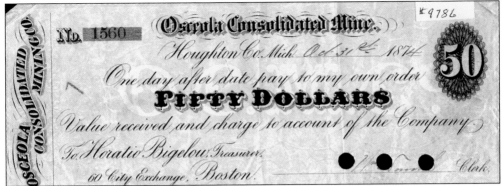

Bathhouses, schools, and even land and subsidies for churches were offered by all but the smallest mining companies. Company-run stores provided food and consumer goods that could be purchased with either company scrip or dollars. Compared to the opportunities that existed on the farms or other industries of the day, the mining companies' program was wonderful by 19th-century standards.

The downside of the mines' paternalistic management was twofold. One, the working conditions were brutish at best. If a man died in a mine, his wife got $500 and an invitation to vacate the company home after a short grieving period. Two, while workers lived in relatively primitive accommodations, the mine bosses lived in homes like this, occupied by a Quincy superintendent and provided by the company.

Here, the Quincy "management ladies" pose in their finery on an excursion at Portage Lake around 1880. This image reflects the women's affluence and the fact that company-paid servants cared for their company-provided homes. The workers' wives, on the other hand, were set to a life of drudgery. In many cases, miners' wives had to care for not only their own families, but for the children and widows of miners who had been killed in accidents.

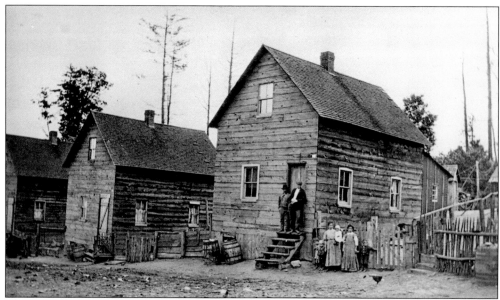

This typical company dwelling was provided to Serbian immigrant workers by the Copper Range Mining Company, just outside Painesdale in an area called Seeberville. During the strike of 1913, the home was the site of an unprovoked fatal shooting of two workers and the injury of a child by hired toughs provided to the mining company by a New York security firm, Waddell-Mahon.

When Ingersoll-Rand introduced the single-man compressed-air mining drill in 1912, the mines embraced it as a godsend to profitability. The workers, who also had issues around workday length and minimum wage, were incited to strike by these "widowmaker" drills. Under the banner of unsafe working conditions, the Western Federation of Miners, who had organized copper, lead, and gold mines in the West, looked upon this as a key issue to organize the copper mines. (Postcard by W. H. Forster, Calumet.)

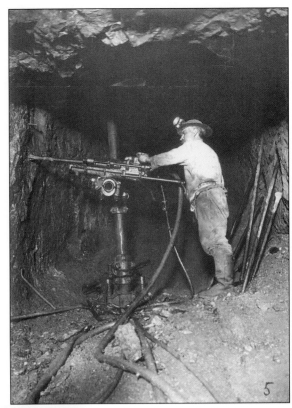

James McNaughton, superintendent of the Calumet and Hecla Mining Company and spokesman for the unified mine owners, stated there would be "no negotiation with the Western Miners Federation." In response, on July 23, 1913, miners went on strike in Calumet and all other mines in the district. McNaughton was a larger-than-life individual, a hard-headed Scot; as a manager for Western Mines, he had previously had problems with the Western Federation of Miners before joining C&H.

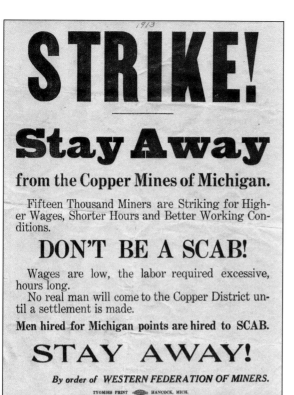

STRIKE!

Stay Away

from the Copper Mines of Michigan.

Fifteen Thousand Miners are Striking for Higher Wages, Shorter Hours and Better Working Conditions.

DON'T BE A SCAB!

Wages are low, the labor required excessive, hours long.

No real man will come to the Copper District until a settlement is made.

Men hired for Michigan points are hired to SCAB.

STAY AWAY!

By order of **WESTERN FEDERATION OF MINERS.**

TYOMIES PRINT ◄═══► HANCOCK, MICH.

Immediately after the strike was called, the company put out a call for workers to take the jobs of the striking miners and surface workers. "Scabs," as these despised workers were called, were subject to threat and in some cases actual bodily harm.

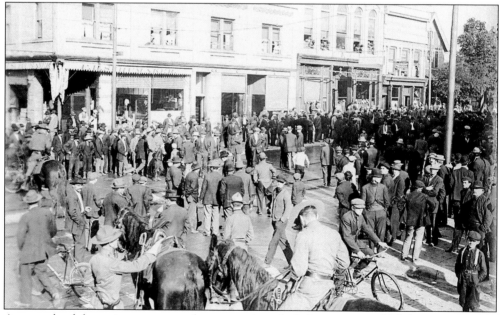

As a result of these circumstances, the companies asked the governor of Michigan to send in the National Guard. It is hard to verify the necessity of this action and the truth of these times, because the majority of the newspapers were owned by mining company interests. Peaceful marches were often labeled as "riots" and minor incidents of window breaking and trespassing were described as "violent episodes."

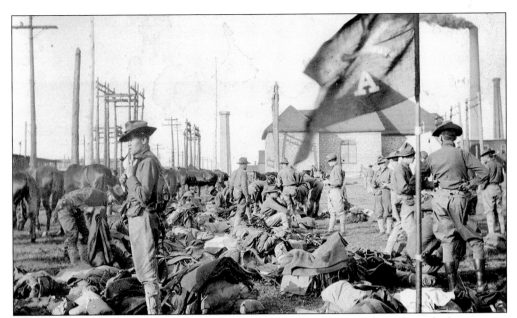

While the National Guard inhabited Calumet and the strike carried on through the summer, encampments were set up on mining company land to protect both the property and the non-striking workers. Here, members of Troop B, 1st Calvary of lower Michigan, set up camp near the C&H pump house.

As the winter of 1913 closed in, the WFM Strike Fund was having trouble keeping up with strike pay, and mine management was still refusing to come to the table. Workers normally would have gathered with their own in the various ethnic neighborhoods, but the devastating financial effects of the strike served to rally the workers, and they joined together at the Italian Hall for a union-sponsored Christmas party.

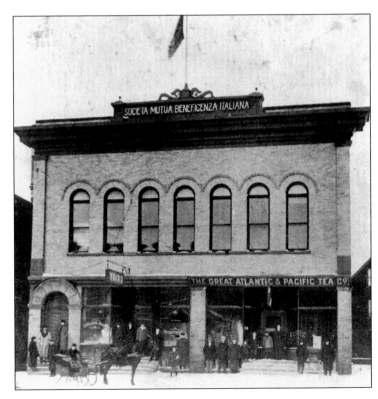

On the evening of the event, in this ballroom, the party was going well. The organizers were on stage passing out presents to the throngs of excited children. Suddenly, the cry "Fire!" was heard, and adults and children stampeded for the narrow stairs leading to in-swinging doors at street level. In the melee, 73 people, including 59 children aged 3 to 16, were crushed and suffocated in the stairwell. (Photograph by J. W. Nara.)

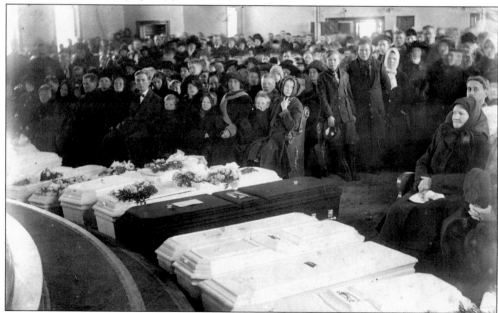

The town buried and memorialized the dead, whom many workers considered were killed by the actions of company-hired thugs. The strike ended Good Friday weekend in April 1914. The men went back to work, and the companies made some concessions as a way to stop more union organizing. It would be 30 more years before a union would succeed in organizing the copper mines. (Photograph by J. W. Nara.)

SUGGESTED READINGS

Benedict, C. Harry. *Red Metal: The Calumet & Hecla Story*. Ann Arbor: University of Michigan Press, 1952.

Chaput, Donald. *Hubbell: A Copper Country Village*. Hancock: John H. Forster Press, 1986.

Clarke, Don H. *Copper Mines of the Keweenaw Series: No. 7 Central Mining Co*. Essexville: D. H. Clarke, 1974.

Hollingsworth, Sandra. *The Atlantic: Copper and Community South of Portage Lake*. Hancock: John H. Forster Press, 1978.

Kilpela, Tauno. *The Hard Rock Mining Era in the Copper Country*. Houghton: Kilpela Publications, 1995.

Lankton, Larry and Charles Hyde. *Old Reliable: An Illustrated History of the Quincy Mining Company*. Hancock: Quincy Mine Hoist Association, 2003.

Monette, Clarence. *The History of Lake Linden, Michigan*. Lake Linden: Some Copper Country History, 2000.

Robinson, Orrin. *Early Days of the Lake Superior Copper Country*. Lake Linden: Houghton County Historical Society, 1994.

Thurner, Arthur W. *Calumet Copper and People: History of a Michigan Mining Community, 1864–1970*. Hancock: Arthur W. Thurner, 1974.

———. *Rebels on the Range: The Michigan Copper Miners Strike of 1913–1914*. Hancock: John H. Forster Press, 1999.

Western Historical Company. *History of the Upper Peninsula of Michigan*. Chicago: Western Historical Company, 1883.

Discover Thousands of Local History Books Featuring Millions of Vintage Images

Arcadia Publishing, the leading local history publisher in the United States, is committed to making history accessible and meaningful through publishing books that celebrate and preserve the heritage of America's people and places.

Find more books like this at
www.arcadiapublishing.com

Search for your hometown history, your old stomping grounds, and even your favorite sports team.

Consistent with our mission to preserve history on a local level, this book was printed in South Carolina on American-made paper and manufactured entirely in the United States. Products carrying the accredited Forest Stewardship Council (FSC) label are printed on 100 percent FSC-certified paper.

MADE IN THE

USA